how to start a home-based

Photography Business

sixth edition

HOME-BASED BUSINESS SERIES

how to start a home-based

Photography Business sixth edition

Kenn Oberrecht
Rosemary DeLucco-Alpert

gpp®
ELISHA D. SMITH PUBLIC LIBRARY
MENASHA, WISCONSIN

Guilford, Connecticut

Text design by Sheryl Kober

Library of Congress Cataloging-in-Publication Data is avaliable on file.

ISBN 978-0-7627-5953-8

Printed in the United States of America
10 9 8 7 6 5 4 3 2 1

Contents

Introduction

People who work out of their homes now represent America's fastest-growing segment of the labor force. And why shouldn't they? Long commutes in bumper-to-bumper traffic are boring, expensive, time-consuming, nerve-wracking, and getting worse every day; mass transit isn't much better.

Meanwhile, technological advances have made working at home far easier and more irresistible than ever. Personal computers have become superfast and powerful. Software programs are advancing so rapidly the hardware manufacturers can't keep up. Fax machines, modems, fiber optics, and satellite links have made global communications practically flawless and nearly instantaneous. And all this functions as readily from a house, condominium, apartment, or mobile home as it does from a complex of corporate offices.

Among the many businesses people can operate out of their homes, photography ranks with the most suitable. Impact on the neighborhood ranges from minimal to nonexistent, start-up costs are relatively low, and it's possible to gradually phase into the business with little financial risk.

So this is a book for photographers—but it's not about photography. Rather, it covers the business of photography and tells you what you need to know about operating such a business from your home. In the chapters that follow, you'll find plenty of solid, practical information and many tips and tricks that will help you tap your photographic skills to earn a living.

—Kenn Oberrecht

A Note from the Sixth-Edition Reviser

It has been a privilege to revise the sixth edition of this book. This is a core hands-on manual and guide for any aspiring photographer who is interested in starting a home-based photography business. My role was to adapt and

update this book in light of the many changes in technology that have come in the twenty-first century. This sixth edition represents the natural evolution the photography industry has taken in the age of digital media and the Internet. The enduring understandings about photography remain true, and the wisdom and experience found here should continue to inspire dedicated photographers.

—Rosemary DeLucco-Alpert

01 Getting Started as a Home-Based Photographer

Photography is not a profession that someone just happens on or stumbles into. Most of us become photographers for the same reason some people become kayakers or whale watchers—because we like it. The big difference is that it's hard to make a living paddling a kayak or waiting for whales to show up, whereas competent professional photographers are always in demand.

Most of us, nevertheless, begin as hobbyists. Some remain casual shutterbugs, content with taking occasional snapshots of friends and family vacations. Most who get serious enough about photography to study the art and craft of it eventually become advanced amateurs or working professionals.

How I Got Started in the Business

As a youngster, I had no idea that photography would play a major role in my life and career. My first camera, a Brownie Box, was a gift from my mother on my eighth birthday, in 1951. That summer my family traveled by car to West Virginia to visit friends, and I remember the frightening scenes of devastation along our route, caused by rampaging floods earlier that spring. I photographed the riverside rubble and recorded sights I'd never seen before. My pictures were primitive but photojournalistic nonetheless.

I saw and photographed my first waterfalls on that trip. Two years later we traveled to Canada to visit relatives in Hamilton, Dundas, and Niagara Falls. I shot more waterfalls, whitewater rivers, and Great Lakes ship traffic. To this day, ship shapes and waterscapes remain favorite subjects.

After high school I spent three years with the Army Security Agency. I bought my first 35mm camera then and carried it on all my travels through New England, Alaska, the South, and the Southwest, shooting mostly landscapes and scenics.

My First Sale

In March 1971, twenty years after I shot my first photograph, I was walking near the Chena River in Fairbanks, Alaska, with a camera bag slung over my shoulder. I was a graduate student in English and journalism at the University of Alaska, enrolled in a photojournalism course, and was growing increasingly weary of subzero weather and scenes dominated by snow.

The river had been frozen since early autumn, but sunny skies and temperatures soaring into the teens promised that spring breakup couldn't be far off. As I walked through a small city park, a sign poking askew from a snowbank caught my eye. Black letters warned passersby: KEEP OFF GRASS. I shot it in black-and-white and moved on, looking for more interesting subjects.

Several days later I handed an 8-by-10 glossy of the sign to Chuck Keim, one of my journalism professors. He laughed, then asked, "Where'd you sell it?"

When I told him I hadn't sold it anywhere or even tried, he asked why I had shot the picture. "I thought it was amusing," I said.

"Don't you think others would also find it amusing?" he asked.

"Well, yeah, I guess," I said, but I wasn't convinced. In fact I felt a little embarrassed walking into the editorial offices of the *Fairbanks Daily News-Miner* to show the print to an editor Professor Keim sent me to see.

"Yeah, yeah, great," the editor said, apparently bored, dismissing me with a sweep of his hand. Unaccustomed to city editors, I mistook his rudeness for rejection. As I turned to head for the door, he called after me, "Give your name and address to the woman at that desk! And your Social Security number! We gotta have your Social Security number!"

I had walked in embarrassed and walked out in disbelief. They had actually bought my simple little picture of a sign sticking out of a snowbank barely a block away from the newspaper office. There it had stood in its cockeyed protest since the first snows of autumn—for anyone to see, for anyone to photograph. The point is, I saw it, I photographed it, and I got paid for it. The picture ran front page, above the fold, on March 9, 1971. It was the first of many photographs and picture stories I would sell to that newspaper.

Two weeks later, spring was on the calendar, but Fairbanks would have none of it. Deep snow had driven hungry moose into the plowed and trampled areas of town and outskirts looking for food. I drove a few miles out of the city in search of picture opportunities. When a young cow moose poked her head through the open

passenger window of my pickup truck, I got one shot off before her breath fogged my wide-angle lens.

The resulting print was no prizewinner, but it showed the moose with the outline of the open window and outside mirror clearly behind her head. It was more interesting than my first sale, and I assumed the local daily would want it. When I showed it to Professor Keim and told him what I intended to do with it, he said, "No, this one should go to Anchorage."

He gave me the name and number of someone at the Associated Press, and that afternoon I put the photograph on the next plane out. Keep in mind that this occurred in the predigital days, when film, negatives, prints, slides, and darkrooms were essential tools of the trade. AP ran it over the wire and paid me ten times what my first sale had brought. I was never again bashful about approaching any editor, art director, or other potential buyer of my photographs.

In Business

That summer, with a course load of only six graduate hours, I was able to freelance part-time. One bedroom of my two-bedroom apartment functioned as an office and studio. The bathroom did double duty as the darkroom.

My professional photographic debut was neither glorious nor glamorous. It was ordinary, mundane. I wasn't winning awards or getting rich, but I was in business.

Until May 1974, when my wife and I left Fairbanks, I continued freelancing—full-time through the summer months and part-time during the academic year.

After a year of traveling through Canada and the United States, we settled on the southern Oregon coast in 1975, in a port town on the sunset slope of the Coast Range. With an endless supply of ships and boats, mountains and waterfalls, beaches and dunes, misty seaports and coastal hideaways, and abundant wildlife everywhere, all my favorite subjects are nearby and daily in my midst.

My home-based business has been a full-time, year-round operation since our arrival in Oregon. I have had to work hard and put in a lot of hours every week, but the trade-offs have been well worth it. Frankly, it hasn't been terribly difficult.

Should You Start Your Own Business?

No one but you can decide whether or not you should start your own photography business, but there are some indicators that might lead you toward the right choice. If the notion of being self-employed as a home-based photographer appeals to you

and you either possess or are willing to attain the necessary skills, you still need to thoroughly question yourself in order to identify your strengths and weaknesses. This is part of the planning stage, a process that's never too early to start and one that should continue throughout the life of your business.

Following are ten questions you need to answer in as much detail as possible before you start your photography business. You probably won't be able to respond to all the questions in one sitting. Those left unanswered will guide you toward your weaknesses or the areas where you simply need to do some work or research or perhaps seek help.

Answer the questions as completely and honestly as possible.

1. *Why do you want to start a home-based photography business?* Provide as many reasons as you can, such as being your own boss, having an opportunity to spend more time with your family, gaining control over your career, getting out of a dead-end job, avoiding the hassles of commuting, and anything else you can think of.

2. *What photographic experience and management skills can you bring to your new business?* List photographic jobs and management positions you've held, courses you've taken, books you've read—and how each has helped to prepare you. If you identify weaknesses in either photographic experience or management skills, state how you plan to overcome them. If you've never held a management position, perhaps your plan to gain the necessary skills will include launching a research effort at your local library and bookstore, taking business courses at a local community college, signing up for seminars offered by a small-business organization or cooperative, or a combination of these.

3. *How much space will you need for your new business?* First, determine what kind of space you will need: office, darkroom, studio, reception area or waiting room, storage area, library. Every home-based business must have some kind of office. Your office can do double duty as a digital darkroom with the right computer hardware and software that will meet your needs. Not every photographer requires a studio, but if you plan to engage in certain kinds of photography, you might. If you specialize in portraiture, you'll need not only a studio but probably some sort of lobby or waiting room for customers as well. You will need a darkroom only if you plan to offer this service to your clients. Nobody ever has enough storage space. After determining your

space requirements, estimate the size in square feet. Allow for furniture and equipment so you'll get an idea of how much space this business is going to take up. (For more information see Chapter 2 under "Setting Up Your Business Space.")

4. *How do you plan to accommodate the space demands of your new business?* Will you temporarily set up a home office at one end of the dining-room table or put a desk in your bedroom and work there? Nothing wrong with that; many home-based professionals start this way. Will you set up a permanent office in an unused room? If you need a darkroom, will you work with a temporary darkroom set up in a bathroom, or are you planning a permanent darkroom? Can your office also serve as a studio and digital darkroom, or do you need separate rooms for these activities? Do you have garage, basement, or attic space you can convert? Can you build on? Everyone will have different answers to these questions, and for some the answers might change within a short time. Renters are more restricted than owners. Those who rent or own small dwellings are more restricted than those who have plenty of space. If you plan to move within five years, you might do well to list short-term and long-term space considerations. (Chapter 7, "Taxes and Recordkeeping," covers the use of a home as a business.)

5. *What are your immediate and future equipment needs, and how will you meet them?* List all photographic equipment you will need to start and operate your business for one year: cameras, lenses, tripods, electronic flash units, external batteries for cameras and flashes, digital memory cards, studio lights and stands, computer (laptop), software, and digital printer and scanner. List all office and other equipment you will need for the same period: telephones including cell phone, fax machine, copy machine, calculator, filing cabinets, office furniture, and vehicle. Similarly, list your projected equipment needs for five years. In each category indicate equipment you already own and how you expect to acquire what you don't have. Keep in mind that in addition to acquiring equipment, you'll probably need to update and upgrade some during your first five years of business. (Also see Chapter 2 under "Setting Up Your Business Space.")

6. *What licenses, permits, and laws do you need to know about to operate a business from your home?* Laws vary from state to state, county to county, and city to city. Your state might require you to file your business name

with a state agency or to apply for a business or vendor's license. You might have to obtain a permit from your county government. There could be city ordinances regulating the operation of home businesses, even from one neighborhood to the next. You need to know about all such obstacles and how you'll overcome them before you go into business. (Chapter 5, "The Legal Aspects of Your Photography Business," offers more information on zoning ordinances, licenses, and permits.)

7. *How much cash will you need to run your business for one year, and where will it come from?* Be honest and as accurate as possible, even though you're making an estimate. Remember: If you must err on money matters, it's always best to err on the side of fiscal conservatism. Overestimate the payables and underestimate the receivables; any outcome to the contrary will be a pleasant surprise. Estimate what it will cost you to run the business for a year, and don't forget to include your own salary as part of the cost. Now determine where the operating capital will come from: savings, spouse's income, pension or retirement income, the business itself, or elsewhere. (For more information on financial matters, see Chapters 3 and 4.)

8. *Who are your competitors, how are they doing, and how do you expect to overtake them in the marketplace?* The way you deal with this question depends on the kinds of photography you plan to engage in and how many others work in the same area. If you plan to do family portraits, weddings, and school pictures, you'll be in competition with every other photographer in your community who does the same kind of work. If they're all driving fancy vehicles and living in expensive houses, there's obviously plenty of room for competition. If they're barely scratching out an existence, it could mean the supply is outstripping the demand, and you may need to look for another niche. Chances are, the truth lies somewhere between the two extremes. If you have a particular area of expertise—say, architectural, product, or industrial photography—in a small community, you could be the only photographer so skilled and might well fill a niche. Spend some time with this question, and answer it carefully. Do your research! This is your first step into the realm of market analysis. (You'll find more marketing information and ideas in Chapter 10, "Marketing Your Photography Business.")

9. *What are the short-term financial and personal goals for your new business?* In other words, what do you expect to earn and accomplish during your

first year of operation? This question relates to Question 1 and goes beyond Question 7. Here you need to focus down, get more specific. You should lay out objectives that go beyond mere subsistence or just getting by. What are you hoping for? What do you expect your income to be by the end of your first year? Will you have others working for you? What sort of hourly or daily rates or on-location fees will you be demanding by then? How will you have improved or branched out? What will you have learned?

10. *What are your long-term financial and personal goals?* Now discuss everything you covered in Question 9 in terms of a five-year plan. How big do you expect your business to be in five years? How skilled a photographer do you hope to be? What sort of clientele do you expect to have by then? Will your business continue to grow, or will you want it to level off at some point? Do you plan to hire help? Will you branch out into other aspects of photography? Will you diversify into other areas?

Amateur vs. Professional

Just as there are amateur athletes who are as skilled as or better than their professional counterparts, many serious amateur photographers are every bit as good as most of the people making a living with cameras. The difference has less to do with proficiency than with what photographers choose to do with it.

The distinction used to be a simple one: Amateurs don't get paid for their work; professionals do. Whether it's a hobby, avocation, or profession, photography is expensive. As a hobbyist, you might be able to offset some of your expenses by selling your work. As a professional, you need to sell enough to pay all your expenses and make a decent profit as well.

One of the most attractive aspects of photography is the possibility of advancing from hobby to career. Many photographers work first for the fun of it, then study and master enough techniques to advance to the level of serious amateur, and ultimately put that knowledge and experience to work earning money. If photography is a serious passion of yours, consider the possibility of turning your passion into a career.

Part-Time vs. Full-Time Photography

The photographer who decides to work as a home-based professional is faced with deciding between part-time and full-time work. I suspect most of us begin working

part-time and gradually or eventually steer our businesses into full-time operations. There are many advantages to starting part-time. Here are some of the options you can exercise:

- Work part-time at home while retaining a full-time job and its steady income.
- Run a part-time home-based photography business and work at another part-time job to make ends meet.
- Retain the benefits package your employer offers while establishing your home-based business.
- Gain professional experience that will prove invaluable when you go full-time.
- Set up adequate business facilities in your spare time without undue financial strains.
- Gradually invest in photographic and business equipment.
- See to numerous details at your leisure, such as a logo, business cards, letterhead, and a domain name for the Web site you will eventually need to create for your business.
- Set up files and establish customer accounts, vendor accounts, and bank accounts.
- Build an excellent credit rating and a solid professional reputation.
- Let your business grow until it's making your projected or required full-time income.
- Build a cash reserve that's big enough to finance your first year's full-time operation.
- Get a feel for the potential of your business and markets before making a major commitment. Research similar businesses in your area.

You can do all this and more as a part-time home-based photographer. You might continue working part-time indefinitely, until you feel like making it a full-time business. Realizing your dream of creating a full-time home-based photography business takes time and commitment. You will need to be organized and efficient with your time. But it is possible as long as you are realistic with your goals.

Acquiring the Knowledge and Skills of Photography

I assume that most people planning on going into business as home-based photographers already possess some photographic skills. You should have some grasp of

basic photographic principles and an abiding interest in learning as much as possible about the profession.

Two good ways to learn are by reading and practicing. Become familiar with all aspects of photography, learn about its history, study different photographers' work that interests you, go to photography lectures and exhibitions, talk with other photographers, join photographic organizations, and take a lot of photographs. Educate yourself in your area of interest.

Taking Courses

My first recommendation is to take a course in basic or advanced photography from a good teacher. Understanding the basic principles of photography is essential. Find a course that fills your needs and level of expertise. Explore local colleges or art centers that offer photography courses. In addition to classes that teach basic photography skills, you might also look into digital photography classes that might be necessary in furthering your skills and what you will be able to offer your clients. Good photography teachers are important. Try to find teachers who have experience working as professional photographers. They are best for sharing insight and hopefully personal experiences that can help direct you in your own work.

Learning by Reading

In the absence of a locally available good basic course, research your public library, Web sites, and bookstores. Browse through the photographic titles until you find a book on basic photography that you understand and enjoy. It should be clearly written and well illustrated. Most important, it should provide you with a firm grasp of the elements of photography: shutter speed and aperture, cameras and lenses, film, filters and lens attachments, light and lighting, composition, digital aspects, and the language of photography.

Publishers tend to produce relatively specialized photography books. Often one book will cover a single topic, such as composition, lighting techniques, portraiture, wildlife, action, or shooting for stock.

John Hedgecoe did an admirable job with *The Photographer's Handbook,* which I can happily recommend. While this is a basic, general text, it's an in-depth work that contains much that beginning, intermediate, and even advanced photographers will find informative and useful. It's a good addition to any photographer's library.

Be sure to visit bookstores in your area to find out what's available. Don't over-look the used-book sections and stores. On the Internet, you can browse the virtual bookshelves at online outlets, such as amazon.com and barnesandnoble.com. There is a lot of information available. Once again do your research and see what books and magazines will best serve your interest and needs.

Workshops and Seminars

You should be able to find workshops and seminars in your part of the country. Some of the traveling schools are excellent sources of information and education. Taking a course, seminar, or workshop is a great way to make connections, network with other photographers, and enhance your skills. There are all kinds of courses and workshops at various levels of interest and technical abilities offered (see the Source Directory at the back of this book, under "Courses, Seminars, Schools, and Workshops").

Correspondence Study

Correspondence study is another way to learn photography. This type of study calls for motivation, self-discipline, and a commitment to learning—identical require-ments for anyone who intends to operate a home-based photography business.

The New York Institute of Photography offers a program of correspondence study that gets high marks from those who have investigated or enrolled in it. For details see the Source Directory at the back of this book, under "Courses, Seminars, Schools, and Workshops."

Internship/Photographer's Assistant

Finding an internship with a photographer is a great way to learn how to run a photography business. Internships are usually unpaid positions, but you can learn invaluable information.

Working as a photographer's assistant requires more advanced photographic skills and knowledge than working as an intern, but this can be a productive way to learn the business and see how other photographers work. To find photographers who are looking for an assistant, look up local members of the American Society of Media Photographers (ASMP) (see the Source Directory at the back of this book, under "Associations").

Learning Chemical and Digital Darkroom Techniques

I want to emphasize again the value of a good photography course, especially if you want to learn darkroom techniques. It is not necessary for you to have a "wet" or chemical darkroom to start your home-based photography business, but offering traditional darkroom service would be an added benefit to your business, since most only offer digital darkroom service. It is simply a good idea to have a working knowledge of both chemical and digital darkroom techniques.

Branches of Home-Based Photography

The home-based photographer can work in any area of photography. You can do wedding, portrait, business and industrial, pet and animal, insurance and legal, medical and scientific, or publication photography. You can sell salon prints through galleries and exhibits or do custom lab work for other photographers. You can work as a freelance photojournalist or do all your work for stock agencies.

It's important that you have some idea of the direction you want your business to take, and here again planning is crucial. List all the branches of photography you can think of. Identify those that interest you most. In this simple exercise you may have already identified the branch of photography you are most suited for and might want to specialize in. On the other hand, perhaps you've discovered that your interests are broad and that you are most inclined toward being a general-assignment photographer.

You needn't set out immediately to specialize in anything—or to generalize, for that matter. You may find in a year or two that you're being pulled one way or another. As long as you continue to stay in touch with your own feelings and ambitions, as long as you continue to plan and set realistic goals, and as long as you continue to strive toward photographic excellence, all that remains is to acquire business acumen.

Photographer Turned Manager

Being a self-employed photographer has its advantages and disadvantages. One important advantage is that you have complete control over your time and business. The disadvantage is the time it takes to manage your business can take away from the time you can spend actually taking pictures. A fact you must face at the onset, before you carry this idea of running your own business any further, is that as a self-employed photographer you will probably spend less time behind a camera

than you would working for someone else—serving as staff photographer at a local newspaper, for instance, or as portrait photographer at a major studio. The best you can hope for is that your work will be equally divided between photography and management, so you must have a taste for management.

The photographer who works for someone else need only be good at photography. As the owner of a home-based photography business, you will also have to be a competent manager.

Quick Quiz for the Home-Based Photographer

Before getting down to business, as it were, let's see if you've got the stuff to manage your own photography business. Answer yes or no to the following questions.

	YES	NO
1. Are you a self-starter?	_____	_____
2. Are you willing to work harder and longer than you ever imagined?	_____	_____
3. Do you work well without supervision?	_____	_____
4. Do you work well under pressure?	_____	_____
5. Are you able to organize details?	_____	_____
6. Can you take charge of projects and see them through to completion?	_____	_____
7. Do you have an independent nature?	_____	_____
8. Do you consider yourself well disciplined?	_____	_____
9. Are you willing to make sacrifices to succeed?	_____	_____
10. Do you consider honesty important in business?	_____	_____
11. Do you assume all your business dealings will be with honest people?	_____	_____
12. Do you mind seeing to menial chores?	_____	_____
13. Do you work best as a team member?	_____	_____
14. Are you a procrastinator?	_____	_____
15. Do you think work has to be fun?	_____	_____
16. Are you a creative person?	_____	_____
17. Can you be stern with people who owe you money?	_____	_____
18. Do you consider it necessary to meet or beat all deadlines?	_____	_____

	YES	NO
19. Do you have a firm grasp of photographic principles?	_____	_____
20. Do you own sufficient and adequate photographic equipment?	_____	_____
21. Do you own as much photographic equipment as you'll ever need?	_____	_____
22. Do you know as much about photography as you'll ever need to know?	_____	_____
23. Is the camaraderie of coworkers necessary?	_____	_____
24. Are strict follow-up procedures a waste of time?	_____	_____
25. Are peer recognition and praise essential to your success and happiness?	_____	_____

If you answered *yes* to Questions 1 through 10, *no* to 11 through 15, *yes* to 16 through 20, and *no* to 21 through 25, why aren't you already running your own home-based photography business?

Don't fret if you have some *yes* answers where *no* answers belong, or vice versa. This test was designed to provide a quick self-evaluation and perhaps call to your attention some of the realities of being a self-employed photographer and manager. You might have discovered areas you need to work on. You have probably also found that you're ready to start seriously thinking about and planning for your new business.

Working Out of Your Home

The number of people choosing to work from the home has significantly increased in recent years with the convenience of improved technology and accessibility to information. According to the U.S. Small Business Administration, home-based businesses make up roughly half of all U.S. businesses. The attraction of working out of our home enticed many of us to go into business for ourselves. Working where we live allows us the flexibility to conduct business on our own terms. We can create the working environment that best suits our personal needs. We're able to escape the hassles of daily commuting, which is also better for the environment, and become more productive with the time we are conserving. We can also arrange flexible schedules to accommodate a variety of needs.

The Pros and Cons of Self-Employment

For most of us who have been in business awhile, the advantages of home-based self-employment far outstrip the disadvantages. You ought to know at the onset, though, that some people just don't take to this kind of life. So approach your business cautiously, and weigh the options carefully.

Two attributes—self-motivation and self-discipline—work hand in hand and are essential to the success of any home-based business. Of course you must be motivated and disciplined in most areas of your life, both personally and professionally, to have a productive life. But an extra amount of effort is needed to successfully run a home-based business. If you have difficulty with self-motivation or self-discipline, you will need to address this before making a full-time commitment. If sleeping in or taking a day or afternoon off might cause you to miss a deadline, then don't do it. If, on the other hand, you've been working hard and taking a little time off will do no harm, then the

decision is up to you. Keep in mind, though, that when you miss a morning, after-noon, or entire day, all your business activities screech to a halt; the work won't get done in your absence. You might have to put in some evenings or weekend time to catch up. So every time you're tempted, ask yourself if it's worth it.

The Balancing Act

Working from home has many advantages, but you must be able to balance your needs with those of other people who live in the home. If you live alone, you can create whatever environment works best for you. If, however, you live with others, you will need to work together to designate space and time for your business.

When you work from home it is easy to be distracted by daily chores, errands, phone calls, personal e-mails, and other situations that can take you away from work commitments. This is where self-discipline and motivation come into play. Find a balance that will work for you and your family with the time and space your business will occupy in the home. It may take some time to come up with a system that works best for everyone involved.

Creative Work Schedule

Many who aspire toward the independence of running their own home-based businesses dream of the day when they can eliminate the daily routine: no more Monday-through-Friday, nine-to-five grind. That's true. Your home-based photography business will probably require a Monday-through-Saturday schedule, with plenty of Sundays thrown in. Your schedule may also vary seasonally. If and when you have downtime, focus on areas of your business that need attention, like meeting with prospective clients or working on new promotional materials. It is still important to have a daily schedule and routine, but it can be one that works for you, not one that is designated by someone else.

No More Bosses

Yes, photography is a service industry and you will be "working" for others, but you will still be your own boss. You will make decisions for yourself about how to best serve your clients' needs. Integrity is key. Be the best you can be and treat others with respect. Word of mouth is the best advertising for a photographer. Working cooperatively with others to create the best results possible should be your ultimate goal. Always remember: You are in control of your own success.

Isolation—Curse or Blessing?

Isolation is also something every home-based photographer must deal with. Oddly, the reality of it comes as a surprise to many people who decide to run businesses from their homes. Some are truly distraught by being cut off from daily interaction with others, particularly those who leave busy jobs where isolation is rare or nonexistent. The rest of us revel in the solitude and the high level of productivity it fosters.

If most of your business is local, you will come in contact with more people than if the bulk of your work is for distant clients. Even in the latter case, you'll need to stay in touch with people by phone, mail, fax, and e-mail, and with the occasional business trip, trade show, or association meeting.

If your photography business is one that requires meetings with clients, you might consider luncheon meetings as a way of getting away from home for an hour or so. This can be a refreshing diversion if you don't mind dividing your workday to allow it. Breakfast meetings can be a good alternative if you don't like to break up your workday.

Another way to alleviate isolation is to seek out and connect with other individuals who have home-based businesses in your area. Your local chamber of commerce might be a good place to connect with others, and it offers a good possibility for networking. Part of any business is promotion, so get out there, meet people, and tell them about your business.

Setting Up Your Business Space

One of the first orders of business is to plan, design, and set up your work space. This is a matter of both logistics and legalities. Your business will require a certain amount of space. Your home may or may not impose space restrictions on your business. In order to qualify as a legitimate business for tax purposes, the space you set aside will have to meet certain criteria. (Also see Chapter 7, under "Using Your Home for Your Business.")

The advantages of converting part of your home to work space far outweigh the alternative, which is to rent or lease business space. Typically, commercial space rentals can range from approximately $15 to $20 a square foot per month and sometimes much more, especially in large cities. If you want to know how much commercial space costs in your area, check with a local Realtor for commercial rental prices. Be sure to consider that these prices may not include utilities and phone/Internet services.

Every professional photographer, however, needs a place to conduct business: to see to correspondence, accounts payable, accounts receivable, the endless flow of paperwork, and all the other chores of business. Whether this turns out to be one end of the dining-room table, a desk in a corner of a bedroom, or a full-fledged home office depends on what you need and what's available.

One of the beauties of the home-based photography business is that you can start small. Even though photography is relatively expensive at any level, you don't need as much equipment and materials as you might in another kind of business. You need reliable photography equipment to get started, along with backup cameras and flash units, and you need to set up some sort of office space. And there's nothing wrong with using part of another room in your home, except that you may not claim that space as a home office when you file your tax return. Any space you set up in your home for the purpose of running a business must be used *regularly* and *exclusively* for that business if you are going to claim a deduction for it. If you can, though, try to convert any available rooms, add on, or plan for the additional space the next time you move or build. It's better not only for tax purposes, but also for doing business and keeping your business and personal life separate. You will have a discrete, clearly defined place to go to work, to conduct business, and, perhaps most important, to leave at the end of the workday.

As in any other planning operation, you need to put this on paper. You should write out your wants and needs, and sketch out floor plans that will accommodate your physical requirements.

There never seems to be enough storage room, so plan accordingly. When we moved into a town house, I got along fine for about a year, but then I had to rent additional storage space. When we built the house we now occupy, we planned carefully and thought we'd never run out of space. I'm now considering a major physical reorganization of my business that will probably include the building of a separate storage facility.

In planning the physical structure of your business, pay close attention to your equipment requirements. List your immediate needs for each aspect of your business and note how you intend to fill them. You might also list your midrange and long-term needs. If you answered the series of questions near the beginning of Chapter 1, you have already made such a list in response to Question 5. Following are some hints that may help you in this process.

The Home Office

The bare essentials for any home office include a desk, chair, filing cabinet, wastebasket, telephone, fax machine, and computer with appropriate software. You will probably want a bookcase or bookshelves and perhaps a storage cabinet. Most of us also need some kind of calculator. To keep track of important names, mailing addresses, phone numbers, e-mail addresses, and Web sites, you should have some sort of index. There are a variety of computer software programs you can use to retrieve such information electronically.

Required office materials vary from one business to another but certainly include various paper products, staples, paper clips, spring clips, assorted adhesive tapes, mailing and shipping labels, printer and ink, rubber bands, batteries, and file folders.

Paper products I use include scratch pads, Post-it Notes, letter-size ruled pads, printer paper, copy-machine paper, graph paper, letterhead stationery and envelopes, business cards, 3 x 5-inch index cards, self-adhesive labels in assorted sizes, chipboard and cardboard stiffeners (for protecting photographs in the mail), large mailing envelopes in different sizes, padded mailers, and various printed forms.

You will eventually discover other tools and materials that, while not indispensable, certainly save time, money, and effort. As any professional photographer does, I use a lot of batteries and have switched to various types of rechargeable batteries for most of my needs. Generally, rechargeable batteries save money and are kinder to the environment.

A good phone system is also essential. It should have an answering machine, speaker phone, and phone-number storage. You will want to do your research with local phone carriers to try to find one that can combine your phone and Internet needs in one package. This may save you money as you set up your business. Always be sure to ask carriers if they offer discount packages for start-up businesses.

Try to design as much horizontal working surface as possible into your home office. Desktops are never large enough, so plan for more surface space than a single desk offers. Perhaps add a worktable, a credenza, or even a second desk. A great idea is to rest a flat door on top of two filing cabinets at either end. This makes an inexpensive usable work space with storage underneath.

The Home Studio

The studio is probably the most variable room of all among home-based photographers. You may not need one at all, but if you do, you must determine how you will

use it in order to know how much space you will need and how you will furnish it. If you do nothing but tabletop and small-product photography, your requirements will be minimal. You may even get by with a small studio arrangement in a corner of your office. If you plan to shoot portraits and family pictures, large objects, or complicated setups, you'll need more space.

The minimum space for portraits should be about eight feet wide by ten to twelve feet deep to accommodate backgrounds, lights, and camera equipment. If you intend to specialize in portraits and family pictures, plan for considerably larger dimensions, because you'll need room for bulky equipment and props.

For starters you'll want some kind of equipment to hold seamless background paper. Simple telescopic stands that extend to eight feet are probably the cheapest option. For still lifes and tabletop and product photography, a setup table or light table works well and needn't cost much. You can also start small with studio lighting. You'll need a minimum of two lights with stands. Eventually you'll want to add more for special purposes and creative lighting options. While it's possible to spend $1,000 or more on a single light head, with some careful buying you can put together a three-light outfit with telescopic stands for under $500.

Buy a heavy-duty, twenty-five-foot extension cord. Then fit it with an industrial-grade multi-outlet strip. Get a strip with six outlets, on-off switch, pilot light, and circuit breaker. If you use expensive lights and other electrical equipment in your studio, invest in one of the more expensive multi-outlet strips that includes a surge suppressor. Additional power supply units for your studio lights will also be helpful.

All that remains to complete your start-up studio is a camera and tripod, which you should already have. Later additions and upgrades will depend on what level of studio photography you hope to achieve.

The Home Wet or Digital Darkroom

With advances in digital technology, you have the choice of investing in either a wet or digital darkroom. Most professional photographers today work digitally.

Time, space, and finances are important elements to consider in setting up your darkroom. Think about your clients and what type of photographic services you will be offering them. Do you need a wet darkroom? Do you have the space and time you need to develop film and print photographs? Will most of your work be digital? To help you in your decision, research the services your competition offers.

When it comes to setting up your darkroom, be realistic with your initial investment; you can always make changes as your business progresses. The following will review the basic needs in setting up wet and digital darkrooms. Take time to educate yourself before you invest in any equipment for either setup.

Wet Darkroom

Whether you set up a temporary or permanent darkroom, the basic requirements are the same. To begin, you'll need a room that is light tight and has access to plumbing. Equipment needs are fairly standard. For developing roll film, you'll need at least one developing tank and reel, along with film clips for hanging and drying film. Film-developing chemicals can be stored in one-gallon brown plastic jugs, one jug each for developer, stop bath, fixer, and rapid-wash hypo-clearing agent. Other essential film-developing equipment includes a good darkroom thermometer, a lab timer, graduates for measuring and mixing chemicals, a two-gallon bucket, a stirring paddle, a filter funnel, scissors, and an opener for 35mm film (a can and bottle opener works fine).

For black-and-white photography, necessary equipment includes an enlarger, an enlarger timer, safe light(s), a print easel, three chemical trays, three print tongs, a print washer, and some sort of print dryer. You'll also use some of the same equipment you use in film developing, such as a thermometer and graduates.

Digital Darkroom

The most important element of a digital darkroom is a relatively fast computer with a lot of memory and a monitor. The computer runs the software and controls the monitor, printer, storage, and any other device needed to assist in your digital workflow. The monitor displays digital-imaging software tools as well as the images you are working on or those that have been sent to you. You will also need a card reader that connects to your computer for transferring images. A scanner can be helpful if you plan to work with slides, negatives, or prints and want to transfer them to your computer.

There are a variety of software programs available to photographers, and which ones you choose depend on what you want to do. For example, Apple's Aperture and Adobe Photoshop Lightroom both assist with photo management, and Adobe Photoshop allows you to manipulate still images.

External storage devices are also important for digital darkrooms. Storage devices such as flash drives, external hard drives, and compact disc (CD) or digital video disc

(DVD) archive files can assist in the storage, exchange, and/or transport of digital files. A digital printer produces prints or images that you have on your computer.

There are many choices in purchasing darkroom equipment. Once again, do your research to figure out what you will need to get started and what would best serve your clients. Just as with your camera equipment, darkroom equipment is another essential investment in your business.

Handling Growth

There's nothing wrong with modest beginnings. In fact, I'd recommend you start that way. It's always a good idea to be realistic with your initial goals and plan ahead for further growth. And if you operate your photography business with intelligence and integrity, it will grow. Building your clientele takes time and commitment. You can pace your growth according to your abilities, resources, and available space.

Many entrepreneurs equate growth with success and insist that in order to succeed, a business must grow, which is true to some extent. It is important for a business to grow during its formative years. It can be dangerous, however, to extend the growth notion too far, to think that the faster a business grows, the more successful it will be—or to believe that if a business doesn't continue to grow, it is destined to fail.

It's actually possible to grow too fast—that is, to take on more than you can handle. Be sure the prices you quote to clients or customers are based on a realistic time frame and workload you can handle. If not, this will not only reduce or eliminate your profits but will also affect your operating capital. Be realistic about your abilities, what you can handle, and what time you will need to meet deadlines. As you begin your business, you will learn from your mistakes. This will help you refine your business practices. To further your growth, you may eventually need to hire an assistant or office help.

Working with Others

As your business grows, you might discover there are times when you need additional assistance and seven days aren't enough to get the week's work done. A number of factors can contribute to scheduling issues and the need for careful reevaluation of your business's labor requirements.

- *Seasonal aspects.* You may find that there are times of the year when you have more work than you can handle. Portrait photographers, for example, are often busiest just before and during the Christmas holidays. School

photography can put strains on your time and resources. Even travel and outdoor photography have seasonal peaks the photographer must consider and learn to deal with.

- *Rush orders.* You won't be in business long before you discover that few customers and clients plan ahead. Everybody, it seems, needs it done yesterday. And there are times when, for whatever reason, work needs to be delivered immediately.
- *Special projects.* From time to time you will probably land jobs outside of or in addition to your usual business. Often these can be lucrative jobs that you can't afford to turn down. Indeed, you might pursue or even initiate them yourself. As well as they may pay, they can put additional demands on your business that call for extraordinary measures.
- *Accumulated chores.* Dealing with all the above problems will force you to set priorities and to put off low-priority tasks until time permits you to address them. These lesser jobs can eventually grow into a major responsibility that must be dealt with.

When faced with these or similar circumstances, you have several choices. If you need help with your work, you may have to consider hiring help. Depending on your needs, it may be temporary or more permanent assistance.

Often, hiring permanent help only adds to your burdens, and I must recommend you do so only as a last resort. You'll probably need to advertise to find help. Then you'll have to screen and interview prospective employees. In order to attract competent applicants, you'll have to offer a competitive wage and certain fringe benefits. Consider your options carefully before hiring a permanent employee. Check with state and federal regulations on what is required from you as the employer. It may be more costly in the long run, but if you are at the point where you cannot do all that is required to run your business, this may be a necessary part of your growth. The possibility of hiring a permanent part-time employee to help run your photography business may be to your benefit, even during the slower times. For example, a part-time employee could assist you with important marketing projects.

Hiring Temporary Help

You may also consider hiring temporary help through an employment service, not to be confused with an employment agency. Employment services are companies that

provide workers for other businesses. The employment service tests, screens, hires, and trains the workers; pays their salaries; provides all their benefits; makes all the necessary payroll deductions; and sees to all the necessary paperwork.

Well before you have an actual need, you should find out what sort of temporary help is available in your locale. Check with the local chamber of commerce or Small Business Development Center. Most such companies have an employee pool with a wide range of skills in a variety of fields. Most have clerical help and skilled office workers available, and some have people competent in certain specialty areas.

When you use an employment service, you pay an hourly rate to the service, which then pays the employee and keeps a portion for the service. The rate you pay obviously must be higher than what you might pay an employee you hire yourself, but probably will work out to be a better deal for you in the final analysis. You will avoid all the time-consuming chores and paperwork associated with advertising for, interviewing, screening, training, and paying an employee.

Independent Contractors/Photography Assistant

An alternative to hiring help is to use the services of an independent contractor or freelance, photography assistant—someone who, like you, is self-employed and works by the job or by the hour, under contract. You and the contractor agree in writing to what the job entails and how much you will pay. The contractor is then responsible for doing the work as stipulated, paying self-employment and income taxes, and filing the necessary forms.

If you use independent contractors in your work, there is one form you might have to file. The Internal Revenue Service requires you to file a Form 1099 for any independent contractor you pay more than $600 during a tax year.

Your need for a freelance photography assistant may vary from job to job and the length of time you need the help may also vary. You can find reliable freelancers in a variety of ways; be creative in finding help that you need. Word of mouth is one way. If appropriate, ask other photographers whom they have used and have been happy with. Or visit your local ASMP Web site (see Source Directory); they may have a listing of available freelance photography assistants in your area. If there is a photography program at a local college, get in touch with them to see if any students are interested in getting experience. Students may even work for free as part of an internship program. Remember that others might be in the same situation that you

were in before you started your business, looking to gain valuable experience and willing to work hard to learn these skills.

Collaborating with Others

Collaboration is another way to get help on jobs without hiring employees. In a collaboration you work with one or more other persons to complete a project. For example, you might work with another photographer on a major shoot, or you might work with a writer on a project for publication that requires text and photography. An annual report for a large corporation might require a team of writers, photographers, and illustrators and someone to manage the team and coordinate its efforts.

Separating Business Life from Personal Life

I have read that it's impossible for the home-based entrepreneur to keep business life and personal life separate. To the extent that no business or job can be kept entirely isolated from personal and family affairs, I would agree. But it's essential for the success of your business and the well-being of your personal life that you make every effort to keep the two distinct and apart.

If you have a family, your home-based business is going to affect it in some way, and vice versa. If your business is only in the preliminary planning stages, waste no time in bringing certain family members on board and making clear to them what your plans are and how they might affect family life. A spouse should be part of your planning from the start.

Most important, you must make it clear to your family, friends, and neighbors that although you will be working at home in your new business, you are indeed working and during work hours you are not available for chores, babysitting, shopping, running a shuttle service, or doing anything else not related to professional photography.

With more people running home-based businesses, the understanding of others has increased. However, there will always be people a little skeptical about how you fill your days and why you aren't always available, since you are "just working out of you house." It's possible that the skeptics are individuals who are simply not disciplined enough to take on a challenge such as this. Your organizational skills will be key to your success in running a home-based business. Distractions will always be there, especially when working from home. This is why it is extremely important for you to have a daily schedule and routine that sets apart your professional and personal time.

03

Financial Planning

In the broadest sense, the operation of any business can be divided into two basic categories: the management of money and the management of time. Although the two are inextricably intertwined, you should first expend your efforts toward planning and managing financial matters.

For most people, starting a new business involves a great deal of guess-work. I suspect that's one reason so many small businesses soon end up in financial difficulty. As I said earlier, the home-based photographer has the distinct advantage of being able to operate part-time before starting a full-time business. The ability to analyze revenues and expenditures from the part-time business and extrapolate them to reflect full-time operation removes much of the speculation and makes financial planning more accurate and management much easier.

Even if you start your business on a part-time basis, you must not treat it as a hobby. I suspect that most photographers who decide to set themselves up in business were first serious amateurs who sold enough work to buy photography equipment and materials and offset the costs of an expensive hobby. A business—part-time or full-time—must do more than that. It must generate sufficient revenue to cover expenditures and make a profit.

It's never too soon to begin planning and managing finances. If you're a hobbyist looking forward to turning your hobby into a business, begin keeping good records immediately. Learn exactly what everything costs, and keep track of price increases. Conduct time studies to learn how long it takes you to do everything associated with photography. Then look for ways to cut costs and reduce time.

Start-Up Costs

Before launching your business, estimate what it will cost you. If you have kept good records of your amateur activities, estimating start-up costs should prove much easier. Nevertheless, it will still require some guessing—albeit guessing based on experience.

Some new entrepreneurs expect the start-up costs of implementing a new business idea to be straightforward and clear cut. Sadly, they are not. There is no way you will determine the exact costs of running a business until you're running it, and even then you must stay alert for potential surprises.

You can greatly reduce the risks and improve the accuracy of your estimates by keeping good records as an amateur and then as a part-time professional.

You'll find that not all the projections, statements, and reports the accountants, consultants, and business writers insist we use are of equal value to all businesses. Even those that are useful operating tools for running your business can be of little or no value in the start-up process. In the pages that follow, however, you'll find some tips that will steer you in the right direction and help you to realistically estimate what starting a new business might cost you.

Schedule of Estimated Start-Up Costs

One document you will need is a schedule of estimated start-up costs. This is no more than a list of all the equipment, materials, supplies, and expenses associated with running your home-based photography business. Compiling the list will force you to dwell on important details you might otherwise ignore, such as what insurance is going to cost you, how much film you'll have to stock, what your phone and utilities will cost—in short, how expensive this business is going to be. The total of all these costs will be the start-up target you'll need to aim for as you plan your business.

Most of the business guides I've reviewed recommend that new entrepreneurs have at least three months' operating capital before launching a new business, and few mention anything about the owner's salary. You will certainly want to include your salary as part of any start-up projection you make. What's more, you ought to have more backing you than a mere three months' worth of funding for a full-time business.

I ran my business part-time until I had a year's salary and expenses in the bank, and all the while I was investing in and upgrading equipment. By the time I was

Estimated Start-Up Costs

1.	Decorating and remodeling	$ _____
2.	Furniture and fixtures	$ _____
3.	Office equipment	$ _____
4.	Photography equipment	$ _____
5.	Computer equipment	$ _____
6.	Vehicle	$ _____
7.	Insurance	$ _____
8.	Licenses and permits	$ _____
9.	Legal and professional fees	$ _____
10.	Office supplies and materials	$ _____
11.	Photography supplies and materials	$ _____
12.	Stationery and business cards	$ _____
13.	Advertising	$ _____
14.	Unexpected expenses	$ _____
	Total estimated start-up costs	$ _____

ready to go full-time, my business was in good shape, and I was able to run it without many financial worries. I suggest you take a similar route, and make sure you have at least six months' salary and operating capital backing you.

Opening Bank Accounts

I've read a number of publications that insist the first thing an entrepreneur should do is head for a bank and open a business checking account. Take your time before rushing into opening a business account. Once again do your research; interview bankers in your area and see what they have to offer a small business owner. Start with the bank you already use for your personal accounts, since you have an established relationship with the bank and possibly an account manager. To start paying bills for your business, if you already have a personal checking account, use it. If not, set one up. If you prefer a business checking account, that's all right, too, but don't establish one for the wrong reasons.

I do recommend that you set up a separate business savings account rather than use a personal savings account for business. The extra account won't cost you anything and will make it easy to keep business funds separate. An alternative is to skip the business savings account and open an interest-bearing checking account for your business. Visit a number of banks and learn what they offer. Then establish the kind of account that provides the most and costs the least.

Don't let the cost of an account be your sole guiding influence. Consider the importance of convenience, simplicity, and service. Establishing a relationship with a local banker can be beneficial to your start as a local home-based business operator. Working directly with someone can help you establish appropriate accounts and build your credit.

The Personal Financial Statement

Do you know what you're worth? Your creditors may want to know, and any institution you approach for a long-term loan certainly will. To answer the question, you should prepare a personal financial statement, also known as a statement of financial condition, or statement of net worth.

This is a relatively simple form with two columns. To prepare it, start by creating a form with your name, address, phone number, and e-mail address centered at the top of the page.

In the left column, list all your assets: cash, checking accounts, savings accounts, real estate, stocks, bonds, securities, and accounts receivable. Also list such assets as vehicles and equipment that have cash value after allowing for depreciation. When you add up this column, you arrive at a figure representing your total assets.

In the right column, list all your liabilities: accounts payable, contracts payable, notes payable, taxes payable, real estate loans, and anything else you owe. When you add up this column, you arrive at a figure representing your total liabilities.

Create a line for net worth. Subtract your total liabilities from your total assets, and enter the result as your net worth.

Keep this statement on hand and update it periodically—at least every year. You will probably want to include it as part of your business plan (covered in Chapter 6).

Columnar Pads for Accounting and Bookkeeping

Those who prefer to conduct all or most aspects of their business on a computer will find a variety of financial-planning programs available. Programs designed for use

Name _____

Address _____

Phone _____

E-mail _____

ASSETS

Cash _____

Checking Accounts _____

Savings Accounts _____

Stocks _____

Bonds _____

Securities _____

Equipment _____

Real Estate _____

Vehicles _____

Accounts Receivable _____

Other Liquid Assets _____

LIABILITIES

Accounts Payable _____

Contracts Payable _____

Notes Payable _____

Taxes Payable _____

Real Estate Loans _____

Vehicle Loans _____

Other Liabilities _____

TOTAL ASSETS _____

TOTAL LIABILITIES _____

NET WORTH _____

(assets minus liabilities)

by accountants and financial planners, however, generally prove to be too expensive and complex for the typical home-based business manager. Simpler, less-expensive programs, such as the popular Quicken products, are much more suitable for small business. You'll find information about the Quicken product line at www.quicken .intuit.com.

Whether you plan to keep books manually or by computer, you may want to try the system that has worked for me for decades.

Accountants usually prepare various statements on columnar pads, the common sizes of which range from $8\frac{1}{2}$ x 11 inches to 14 x 17 inches and include versions with three, four, six, eight, thirteen, and fourteen columns. Use whatever size and format of columnar pad works best for you. I use one size and style of pad for all my accounting and bookkeeping: a vertical-format, four-column pad that measures $8\frac{1}{2}$ x 11 inches. The format and standard letter size make such pads compatible with all my documents and files. They adapt handily to any application. I use them for making monthly, quarterly, annual, midrange, and long-range studies and projections, as well as for all my income-tax records.

Profit-and-Loss Projections and Reports

A profit-and-loss statement (often called a P&L) is an accounting document that measures or predicts your business's operation in terms of net sales or fees, less expenses and other costs, to create an accurate profit picture or reasonable profit prediction. By definition, this document increases in management value with the life of the business, because its degree of accuracy depends on profit history. As defined, it's of marginal value for many start-up businesses.

You can make this a useful management tool if you follow my recommendations. Keeping accurate records of all transactions—income and expenses—during your amateur and part-time days, and logging all the hours you spend working at the business of photography, will create a profit history that you can use to make accurate projections for your full-time business.

You will probably find that the calendar year works best as your business's fiscal year. As you begin, keep records month by month to see the flow of income and expenses. This will give you an estimate of what you can financially anticipate as you begin your business. Until you have at least a year of this information calculated, it is difficult to completely predict what your profits will be. There are many variables that play into the scenario and can affect the outcome. Understand from

Profit-and-Loss Projection/Report (Estimated/Actual)

	JANUARY	FEBRUARY	MARCH	FIRST QUARTER TOTALS
REVENUE				
Services				
Merchandise sales				
TOTAL REVENUE				
COST OF GOODS SOLD				
Materials and supplies				
Outside labor				
Shipping				
Miscellaneous				
TOTAL COST OF GOODS SOLD				
GROSS PROFIT				
EXPENSES				
Wages/salaries				
Payroll deductions				
Advertising				
Vehicle				
Depreciation				
Insurance				
Interest paid				
Legal & professional fees				
Office				
Rent/lease				
Repairs & maintenance				
Supplies				
Permits & licenses				
Travel & entertainment				
Utilities				
Telephone/ Internet service				
Postal expenses				
Dues & publications				
Printing & copying				
Trash collection				
Miscellaneous				
TOTAL EXPENSES				
NET PROFIT (LOSS)				

the beginning that this is a process and a tool that can help you predict what your potential profits can be. Be as accurate with your records as possible. It is simply a good exercise and helps with the overall organization of your finances.

Under Revenue, list all income related to your business, month by month. List income from sale of services and merchandise on separate lines. Add the two and enter a figure for Total Revenue. Under Cost of Goods Sold, list amounts paid for materials and supplies, outside labor, shipping, and miscellaneous costs. Add this column, and enter a figure for Total Cost of Goods Sold.

Subtract Total Cost of Goods Sold from Total Revenue, and enter the result as Gross Profit.

Under Expenses, list wages (including any salary you extract from the business), payroll deductions (if you have employees), and all overhead and other expenses associated with operating your business. Personalize your expense list; the P&L statement shown here is only a guide. For example, you may need to add child-care expenses to your expenses. Add all the items in the Expenses column, and enter the sum as Total Expenses.

Subtract Total Expenses from Gross Profit, and enter the result as your projected or estimated Net Profit (Loss) for that accounting period.

As you progress through your first full year of business, prepare a P&L report at the end of each quarter. These reports should be identical in form to the P&L projections, except that they should reflect actual instead of estimated numbers. Comparing the P&L projections with the P&L reports should help you make more precise estimates in the future and more accurate midrange and long-range projections.

Use your first-year P&L projection as your operating budget. At the end of your first full year of operations, use your P&L reports to adjust your projections and create a month-by-month projection and budget for the upcoming year. Always take into consideration changes in the market and overall economy. Your P&L projection will help you get started and become the basis for your P&L report once you are fully engaged in your home business.

Balance Sheets

A balance sheet is so named because the assets listed in the left column should equal the liabilities in the right column plus the owner's equity. It's a fairly useless document for new businesses and may be of only marginal value for many sole

Balance Sheet

ASSETS

Cash (bank accounts): $ _____

Accounts Receivable: _____

Inventory (if applicable): _____

Prepaid Expenses: _____

Short-Term

 Investments: _____

TOTAL CURRENT

 ASSETS $ _____

FIXED ASSETS

Land: $ _____

Buildings (cost): _____

Less Depreciation: _____

Net Value: _____

Equipment (cost): $ _____

Less Depreciation: _____

Net Value: _____

Furniture/Fixtures: $ _____

Less Depreciation: _____

Net Value: _____

Vehicles (cost): $ _____

Less Depreciation: _____

Net Value: _____

TOTAL FIXED ASSETS $ _____

OTHER ASSETS $ _____

TOTAL ASSETS $ _____

LIABILITIES

Accounts Payable: $ _____

Short-Term Notes: _____

Amount Due on

 Long-Term Notes: _____

Interest Payable: _____

Taxes Payable: _____

Payroll: _____

TOTAL CURRENT

 LIABILITIES $ _____

OWNER'S

EQUITY $ _____

(assets minus liabilities)

TOTAL LIABILITIES

& EQUITY $ _____

Current Date: _____

proprietors (see Chapter 5, "The Legal Aspects of Your Photography Business," for a definition of *sole proprietor*). It might prove useful, however, if you need to seek financing, so you ought to know what it is and how to create one. Of all the analytical and forecasting documents, the balance sheet is the least useful and informative for the home-based photography business.

Balance sheets are usually prepared at the end of the year. The so-called pro forma balance sheet is one prepared in advance of the coming year or accounting period and is hypothetical in nature.

Cash-Flow Projections and Reports

Cash flow is more than net profit; it's how money moves into and out of a business. It covers all business income and cash reserves after expenditures and can indicate the timing of cash movement.

For your business to succeed, it's essential that you ensure a steady and substantial income, not only to pay business expenses and to buy materials and equipment but also to provide you with an adequate personal income and benefits.

You must keep track of cash flow by regular reporting of income and expenditures. In most businesses this is done monthly, with quarterly and yearly totals included. Accurate and timely records enable you to track cash flow and forecast future needs and trends, which allow you to make intelligent capital investments and ward off potential problems or interruptions of cash flow.

Cash-flow projections and reports are similar in form and format to P&L projections and reports. In fact they're similar in content, but with two important exceptions. P&L projections and reports are designed to provide estimated and actual net profits before taxes, and they do not include cash-reserve information. Cash-flow projections and reports provide estimated and actual after-tax profits plus available cash reserves to indicate a cash position at the end of an accounting period: month, quarter, year.

To prepare a cash-flow projection for one year, you can use a sheet from a thirteen-column pad, or four sheets from a four-column pad, as I do. As with the P&L projections and reports, every four-column page provides a column each for three months and one column for quarter totals.

In the left column, Item 1 should be Cash on Hand as of the first of the month. This includes any amount of currency earmarked for business purposes, as well as amounts in any business bank accounts.

	JANUARY	FEBRUARY	MARCH	FIRST QUARTER TOTALS
1. CASH ON HAND (first of month)				
2. CASH RECEIPTS				
a. Cash Sales				
b. Collected Receivables				
c. Other				
3. TOTAL CASH RECEIPTS				
4. TOTAL CASH AVAILABLE				
5. CASH EXPENDITURES				
a. Gross Wages				
b. Taxes				
c. Materials				
d. Supplies (office, etc.)				
e. Services (lab, etc.)				
f. Repairs & Maintenance				
g. Advertising				
h. Vehicle				
i. Travel & Entertainment				
j. Accounting & Legal				
k. Rent				
l. Telephone/ Internet Service				
m. Utilities				
n. Insurance				
o. Printing & Copying				
p. Postage				
q. UPS, FedEx, etc.				
r. Dues & Publications				
s. Miscellaneous				
t. Other				
u. Subtotal				
v. Capital Expenditures				
6. TOTAL CASH PAID (u. plus v.)				
7. CASH POSITION (4 minus 6)				

Item 2 is Cash Receipts for the month, itemized as cash sales, collected receivables, and any other receipts, including any cash infusion, as from your business savings, the sale of capital equipment, or any other source.

Item 3 is Total Cash Receipts. Add Item 1 and Item 3, and enter that figure as Item 4: Total Cash Available.

Item 5 is Cash Expenditures. Under that heading, itemize and list all cash that your business had to pay out during that accounting period, including all wages (yours and any others'), taxes, expenses, and overhead. You can modify this listing to suit your needs. In my own cash-flow projection, I have itemized subheads alphabetically listed from a to v.

Item 6 is Total Cash Paid, the sum of everything listed under Cash Expenditures. Subtract Item 6 from Item 4, and enter the result as Item 7: Cash Position.

At the end of any accounting period, when Total Cash Available is greater than Total Cash Paid, a positive figure will represent your Cash Position. If Total Cash Paid is greater than Total Cash Available, your Cash Position will be a negative figure, also referred to as negative cash flow.

The purpose of the cash-flow projection is to identify any negative cash position so you can take action to rectify the situation.

As with the P&L documents, you should also prepare a cash-flow report, which is identical to the cash-flow projection except that it reflects actual instead of estimated figures. Regularly comparing the two documents helps you become more accurate in your forecasting.

I know that, barring unforeseen catastrophe, my most troublesome months will be June and December. They have been for well over fifteen years and will probably continue to be. For some years November has been my third most expensive month, and May has come up a close fourth.

Not only can I predict which months might slip into a negative-cash position, but I also know why. In June and December, in addition to all the usual expenses, I have several hefty semiannual and annual bills to pay—mainly insurance premiums. Also, spring and fall are my busiest seasons for outdoor and travel photography, so I'm on the road a good bit then. I always charge my fuel and motel bills to credit cards. I use a lot of film then and must constantly replenish my photographic supplies. It can take from thirty to sixty days for all these charges to show up on my credit-card bills. Those arriving earliest are usually due in May and November, but the bulk of them end up in my accounts-payable file in June and December.

Cash-flow analysis can be much more complicated and usually is for larger, more complex businesses. Sadly, some writers, consultants, and educators insist that the topic be just as cumbersome and confusing for owners of small businesses. They tend to make it an academic exercise that serves little practical purpose for the home-based photographer. Try to keep it as simple as possible.

Credit and Borrowing

Although many entrepreneurs start businesses on borrowed capital, I want to warn you away from this practice. Instead of borrowing start-up cash, work part-time, invest in equipment, and build a substantial savings account before launching your full-time business. Don't start with long-term debt.

Short-term debt is another matter, and it takes many shapes. Every time you pay for a tank of gas with a credit card, you aren't really paying for it but instead are putting off payment until the company sends you a bill. Likewise with the motel bill you put on an American Express card, the photo paper order you charge to a Visa, or the lens you put on a MasterCard. When you charge office and photography supplies and materials to accounts you have established with vendors, you also take on short-term debt.

This form of borrowing not only is an acceptable practice but, when properly managed, can also offer a number of advantages. Credit cards and vendor accounts can be a great aid to bookkeeping. They eliminate the need to keep large amounts of cash on hand and reduce the number of checks you have to write. They also speed up delivery of mail orders, because your supplier can ship immediately instead of waiting for a check to clear. If you run into a problem with a supplier, you stand a better chance of getting quick satisfaction if you charged your order to a credit card—such as Visa, MasterCard, or American Express—because your credit-card company will contact the supplier on your behalf, which not only saves you time and trouble but also exerts more pressure on the supplier.

I highly recommended that you pay all your credit-card and other accounts in full as the bills arrive. By doing so you will soon build a good credit rating that will serve you well if you need to seek long-term financing. Even if you adopt the policy of avoiding long-term debt, you may sometime face the need to borrow for your business. For example, you might have to replace an expensive piece of photographic equipment, upgrade a computer system, or buy a new vehicle. Sometimes it's impossible to make such high-ticket purchases without a long-term loan.

You could also land contracts that force you to borrow for capital investment. For example, doing the best and most cost-effective job may hinge on your owning certain equipment—perhaps an expensive lens or another camera body. Or it could be that just as you are trying to get a few more months' use out of your business vehicle, you land a job requiring considerable travel. These are times when borrowing now could pay off handsomely later.

Under such circumstances be sure to shop around for the best interest rates. Before you visit bankers, head for your local Small Business Development Center (SBDC), visit the U.S. Small Business Administration (SBA) Web site, or write to the U.S. SBA for information on their loan programs, such as the guaranteed-loan program, export revolving line of credit, and small-loan program. (See the Source Directory, under "U.S. Government," at the end of this book.) The SBDC can alert you to any other state and federal programs for which you might qualify. Among the most common are special loans for veterans, women, and members of minority groups.

Everybody in the United States who has a credit history is in the computer files of at least one credit-reporting company. It can cost approximately $25 or more for a single report from one of these companies, but you are entitled to one copy of your own credit report free of charge, except for a small handling fee. Your bank should be able to handle the transaction, and I recommend you make this a top priority.

Many people have complained about errors in their credit reports that have caused them trouble getting loans. You need to examine your own credit report to determine your credit rating and the accuracy of information in your report. If you find errors, get them corrected immediately; they can affect your credit rating, interfere with your ability to secure financing, and cause a rash of credit problems for years.

04 Financial Management

No magic formula answers that most popular of questions, "How much should I charge for my products or services?" There are many variables to take into consideration in answering this question. The differences in cost of living, regional considerations, and your own expertise are all elements you need to consider in your equation. Every business is different. One photographer might specialize in weddings and augment his business with graduation, sports, and family portraits. Another might work exclusively as a scenic photographer, selling mainly to calendar and postcard companies. Yet another might be a commercial photographer specializing in architectural photography. Each has his or her own unique set of circumstances that factor into what he or she should charge for services. Only you can determine what to charge for your services or products. Once again, do your research. Use the Internet as a tool; look for photographer associations in the area of your interest and see what information they provide for pricing (see the Source Directory, under "Associations," at the back of this book). Check out other photographers in your region; visit their Web sites to see if they offer pricing information. In the end your pricing policy will be based on what area or areas of photography you work in, how you operate, where you sell your work, and where you do your work.

When figuring out your pricing structure, don't forget to include time allotted for digital processing. This can cut into your overall hourly rate if you do not take it into consideration in your initial pricing. You will also find that you must constantly monitor costs and competition so you will know when and how much to increase your prices.

In some fields of photography, such as shooting for stock agencies or working as a freelance publication photographer, you will have little or nothing to

do with setting prices. When the stock agency sells rights to one of your images, you will get your share of what the agency was able to charge. Be aware that the market for stock photography has changed over the years. With the onset of "free" online photo services, income generated from stock photography has diminished. If you are interested in this area of photography, research various stock agencies to see what they have to offer. In the case of periodical and book publishers, you will get paid each publisher's going rate, unless you negotiate something else prior to submission.

Portrait photographers seem to have the most enviably easy job of pricing. Most calculate their cost of doing business and try to translate that into specific prices for different size prints, usually with price reductions for each subsequent print made from the same negative or digital image. The rationale here is that most of the work goes into producing that first print—setting up and shooting the portrait, developing and handling the film, enlarging, and making the print or manipulating the digital image. After the first print is made, turning out a duplicate requires little more than making an identical enlarger or computer print, or having a commercial lab provide developing and printing services with similar price breaks.

Some portrait photographers charge a sitting fee, which covers all phases of the portrait, up to the point of making the print. Then they charge the same for each print made, no matter how many are ordered.

In certain kinds of photography, the day rate is common. For me, this has proved the best way to bill for my time for on-location photography, such as for advertising, brochure or catalog illustration, and even publication photography financed by a client.

Some publishers' rates are so low, I can't afford to work for them, but if the publisher can entice a company to subsidize the job, I usually end up making top rates and the publisher gets a package from an experienced professional.

Pricing for Profit

Before establishing your own prices, you will have to determine what kinds of photography you will be doing; then research those areas to determine how payment is commonly made and what it amounts to. If you plan to operate a portrait studio from your home, find out what other portrait studios in your area charge. This will provide a basis for your pricing structure—a figure to work with. Then determine how you fit into the community of local portrait photographers.

You don't want to start out as the most expensive photographer in town; nor should you be the cheapest. If your pricing is midrange, you can gradually increase it as your reputation for quality and reliability grows. Even if you are able to work considerably cheaper than other photographers in your locale, undercutting their prices might work against you in two ways. First, your low prices will turn away some potential customers who reason that you get what you pay for. What's more, your low prices might invite your competitors to retaliate.

In my business, income derives primarily from publishers' going rates, royalties, my day rates, hourly jobs, and flat fees. I've had to spend considerable time analyzing my costs and factoring in my required salary to determine how much profit I need to make. You should to do the same, taking into consideration the nature of your particular photography business

Setting Rates

If you plan to do any on-location shooting, you will need to set up some sort of a rate structure for that. Many on-location photographers charge day rates. Some also have half-day rates. My rate structure includes hourly, daily, and weekly rates. I also break my fees into three categories: local, state, and national. In setting your rates, whether for on-location or studio work, you will need to ask several questions. First, how much time will it take you to complete the job? Will you need to hire an assistant? Is there extensive travel involved? Will it be more than one day of shooting? Another factor you have to include in the equation is digital processing time. Even if you are not going to be making prints, preparing digital files to send to clients takes a considerable amount of time, and time is money—especially when you are just getting started with your business. You want to set a rate that you feel comfortable with, that you know is a fair rate for good service. This will help you build your business.

Before you quote rates to clients, ask them detailed questions about what they expect you to do. Have a conversation about their photography needs. This will help you determine your rate. As you begin your home-based photography business, you will need to take time and ask questions before offering quotes, even if you already have a rate in mind. You may want to use the following questions to help open up the communication process in setting your rates. These are just some examples of questions you may want to ask. Your questions should be relevant to your particular subject and area of photography. For example, a wedding photographer would not ask the same questions as a photographer shooting a sporting event.

Quoting Rates: Questions to Ask Clients

1. How will you be using the photographs? For advertising, editorial, or corporate? For Web use or print?
2. What is your time frame/deadline for the project?
3. If on location, do I have access to the location prior to the photo session?
4. If the job requires an assistant (you will need to determine this), are you willing to pay extra for this service?
5. Do you have a specific visual format for the project?
6. Will models be required? If so, who will be responsible for hiring and paying them?
7. Are there any special permits required prior to the photography session?
8. Is there travel involved?
9. Who will be the contact for this job?

Expenses

When quoting rates, make sure to include any and all expenses directly related to the completion of the job. For example, if you have to travel, include your mileage. But as I mentioned, make sure to set a rate that includes time for digital processing.

Overhead

If you're charging by the hour or the day, in addition to charging for materials and expenses directly related to a particular job, you must also charge for the overhead cost: rent, utilities, office supplies, depreciation, and anything else that's not a direct material or labor cost. Of the several ways to calculate the overhead rate, the simplest and most sensible is to derive an hourly rate. You can do this as a part-time or full-time photographer, providing you keep track of all your hours and expenses, as I've recommended.

Let's say that as a part-time home-based photographer, you put one thousand hours into your business the first year of operation. Assume further that your overhead expenses amount to $10,000 for the year. Divide the overhead expenses by the hours to arrive at the hourly value or rate—in this case, $10. Some business managers bill the overhead rate separately, as with direct materials and expenses, and

enter it as a separate line on the invoice. I don't follow this practice or recommend it. Instead, include it as part of your hourly rate or day rate.

If you consider your time as a photographer to be worth, say, $35 per hour, then you would bill your time at $45 dollars per hour to include overhead. Then you can calculate daily and weekly rates based on that starting hourly rate.

Reducing Costs to Increase Profits

The cost of everything that goes into your business's service or product—materials, supplies, overhead, and labor—affects profit. Your costs must be factored into the fees or prices you charge your clients or customers. Excessive costs can make your fees and prices too high to compete effectively. One result is that you could price yourself out of business.

Consequently, you must remain ever alert for ways to reduce costs and thereby keep your profits up. You must also track your costs to know how to charge them. Cost analysis is a continuing process in any well-run business, and the best tools for this job are your P&L projections and reports.

If new business operators have a common fault, it's their overly optimistic view of how their businesses will fare. For that reason it's best to adopt a conservative outlook and management policy.

Managing Accounts Payable

Bills that come due regularly are known as accounts payable. There's more to managing this crucial part of your business than simply writing checks and mailing them. You should do so in a timely fashion, and you must understand the difference between timely and on time. Online banking has become a useful option for monitoring and managing your accounts.

If you merely stack up all your bills and write checks until you have no more money, you aren't managing well. Although most of your bills are probably payable in thirty days, some vendors offer discounts for payment early in the month— usually something in the range of 1 to 5 percent if paid by the tenth of the month, then net after that. Some vendors make their bills payable in thirty days with no discount option. A typical monthly statement might show "Terms: 2% 10 days— Net 30." That means you have ten days from the date of the statement to deduct 2 percent from your bill; after that, you must pay the full amount, and do so within thirty days of the statement date.

Timely Payments

If your checking account has a positive balance, you can just pay all your bills at one sitting. Checks and bills usually arrive throughout the month, not always allowing you to keep a sufficient balance in your checking account. Often a checking account balance might make it through only a portion of the bills and need to await the arrival and deposit of the next batch of receivables.

In such circumstances, sort all your bills into stacks, including those offering discounts for early payment, those offering no discounts, and those offering no discounts and charging late-payment penalties. Obviously, the bills to pay first are the discounted ones. I have several vendors who offer 10 percent discounts and one that offers 20 percent; they get paid first every month. Next, pay those that will penalize you for late payment. That way, if you have a slight interruption of cash flow toward the end of the month, you won't have to miss paying a bill that carries a penalty with it.

When the Buck Stops Short

If you continually come up short at the end of the month, you must make some adjustments in your cash-management practices. You should strive to get all your bills paid on time and in a timely way, but when the buck stops short, you need to take action.

Occasionally letting an outstanding balance slip into the thirty-day past-due category is no big deal and will have little or no effect on your credit rating. Balances that go to sixty days are more serious, and ninety days will have your creditors worrying seriously about you.

If you run into a cash-flow problem, the first thing to do is try to inject cash into your business to rectify it. If that's impossible, or if it might cause more serious problems elsewhere, don't just ignore your bills. Immediately call your creditors to explain the circumstances, assure them that this is a temporary situation that you will correct soon, and provide a date they can count on for full payment.

I ended up in such a position several years ago, after I had placed large orders for office and photographic supplies, counting on a substantial check due from a publisher. The publisher's failure to deliver on time put several of my payables in jeopardy.

I had charged the photographic supplies to a credit card, so I made the minimum payment due and let the balance slip into the high-interest revolving-credit

category. The office supplies were charged to my account with the vendor, to whom I wrote a letter and assured full payment within forty-five days. Three weeks later the publisher's check arrived, and I paid my bill and added a 2 percent late charge. Two weeks later I got a letter from the vendor thanking me for the payment; enclosed was a check refunding the late charge.

Such action will leave your credit rating intact, and it might even improve it. Show your business associates that you're a professional and you'll be treated like one.

Managing Accounts Receivable

Everything owed to you falls into the category of accounts receivable, often just called receivables. Managing receivables is one of the most important aspects of controlling your business's finances.

Get the Cash When You Can

Cash is always best; take it when you can get it. It's impossible, however, to run a photography business without getting involved in credit in one way or another. Whenever you agree to do a job and get paid for it later, you are extending credit. That means credit management is a crucial part of your business.

Billing Practices

Your first step toward managing receivables is to establish systematic billing practices. For most of us, that means stocking and using invoice forms and monthly statement forms. You can pick the forms that best suit your business and have them imprinted with your name, address, phone number, e-mail address, and Web site address. An alternative is to use a computer to design and generate your own forms. Most word-processing software will facilitate form printing, or you can use any of a number of small-business and form-making programs. Some companies offer multipart, preprinted forms and dedicated software to streamline the billing process.

You must adopt a billing policy and be consistent with it. You can use invoices and monthly statements or invoices alone. In the latter case, ask your clients or customers to pay the invoice and include a statement to that effect on the invoice: *This is the only bill you will receive. Please pay the amount due.*

I use invoices and statements, because the statement often serves as a low-key, impersonal dun on accounts that slip into the thirty-days-past category. So I bill each job with an invoice; then at month's end I send a statement to each customer

PHOTO IMAGES UNLIMITED

1492 Columbus Drive ■ Moon Valley, IN 54321 ■ Phone: (123) 555–4545 ■ Fax: (123) 555–6767
E-mail: sallyjohn@homenet.com Web site: www.sallyjohnphoto.com

INVOICE

Bill to: _____ Ship to: _____

_____ _____

_____ _____

_____ _____

Invoice # _____ Date _____

Customer Order # _____ Terms _____

QUANTITY	ITEM/DESCRIPTION	PRICE	AMOUNT
	TOTAL AMOUNT DUE		

2% per month (24% APR) applied to the balance of all accounts after 30 days

PHOTO IMAGES UNLIMITED

1492 Columbus Drive ■ Moon Valley, IN 54321 ■ Phone: (123) 555–4545 ■ Fax: (123) 555–6767
E-mail: sallyjohn@homenet.com Web site: www.sallyjohnphoto.com

INVOICE

Bill to: North Coast Country Inn

P.O. Box 1234

Sandra Linda, CA 95432

Ship to: Molly B. Denim, Manager

North Coast Country Inn

1943 Black Sand Beach Dr.

Sandra Linda, CA 95431

Invoice # I-081510-4

Customer Order # _____

Date August 15, 2010

Terms Net 30 days

QUANTITY	ITEM/DESCRIPTION	PRICE	AMOUNT
1 each	"Wine Country" 16 x 20 print, framed	$250.00	$250.00
1 each	"Redwoods & Rhododendrons" 16 x 20 print, framed	$250.00	$250.00
1 each	"Monarch Elk" 16 x 20 print, framed	$250.00	$250.00
6 each	Assorted Calif. Lighthouse 8 x 10 prints, framed	$125.00	$750.00
6 each	Assorted Calif. Bridge 8 x 10 prints, framed	$125.00	$750.00
2 each	Sunrise/Sunset 11 x 14 prints, framed	$175.00	$350.00
	Total Merchandise		$2,600.00
	Shipping and Handling		50.00
	TOTAL AMOUNT DUE		$2,650.00

2% per month (24% APR) applied to the balance of all accounts after 30 days

PHOTO IMAGES UNLIMITED

1492 Columbus Drive ■ **Moon Valley, IN 54321** ■ **Phone: (123) 555–4545** ■ **Fax: (123) 555–6767**
E-mail: sallyjohn@homenet.com **Web site: www.sallyjohnphoto.com**

STATEMENT

TO: _____ Date _____

_____ Terms _____

_____ Account Number _____

_____ Amount Past Due _____

DATE	INVOICE NUMBER/DESCRIPTION	CHARGES	CREDITS	BALANCE
	BALANCE FORWARD >>>>>>>			
				^^^^^^^

PAY LAST AMOUNT IN THIS COLUMN

2% per month (24% APR) applied to the balance of all accounts after 30 days

PHOTO IMAGES UNLIMITED

1492 Columbus Drive ▪ Moon Valley, IN 54321 ▪ Phone: (123) 555–4545 ▪ Fax: (123) 555–6767
E-mail: sallyjohn@homenet.com Web site: www.sallyjohnphoto.com

STATEMENT

TO: Accounts Payable Department Date August 31, 2010

North Coast Country Inn Terms Net 30 days

P.O. Box 1234 Account Number 000123

Amount Past Due Sandra Linda, CA 95432

DATE	INVOICE NUMBER/DESCRIPTION	CHARGES	CREDITS	BALANCE
	BALANCE FORWARD >>>>>>>			$1,225.00
8/1/05	Invoice #1-080110-2	$1,875.00		$3,100.00
8/10/05	Payment—Thank You		$1,225.00	$1,875.00
8/15/05	Invoice #1-081510-4	$2,650.00		$4,525.00

^^^^^^^

PAY LAST AMOUNT IN THIS COLUMN

2% per month (24% APR) applied to the balance of all accounts after 30 days

or client with an outstanding balance. I spell out all details of the transaction on the invoice. On the subsequent statement, I need only reference each unpaid invoice by number and show the amount due.

Late Charges and Follow-Up

At the bottom of every statement, I rubber-stamp this message in red: *2% per month (24% APR) applied to balance of all accounts after 30 days.* Accounts that go past thirty days get a 2 percent charge added to the balance. After sixty days I also use a bold, red *Past Due* stamp on the statement.

Every account ninety days past due gets the same treatment as the sixty-day account, plus a letter from me insisting on immediate payment. If the account goes to 120 days, I send a demand letter by certified mail, insisting on payment within ten days. The next step is a phone call to my attorney for a ten-day demand letter on his letterhead.

The lawyer's demand letter works nearly every time, but since that one letter will cost me $50, I don't use it for small amounts.

If all those measures fail, I'm faced with the decision to turn the account over to a collection agency or to sue. I have faced such circumstances only twice. In one instance I decided the likelihood of collection was slim and the amount wasn't worth the time and trouble, so I wrote it off. In the other case, the amount was worth going after, but even though I was skeptical about the client's promise to pay, I agreed to let her postpone payment for six more months. Three months later her attorney sent me notice of bankruptcy and invited me to stop by to pick up my check for a penny on the dollar, which wouldn't have paid the fuel for the round-trip. Live and learn.

Purchasing

Purchasing is an ongoing process in any business. You will need to spend money on office supplies, photographic supplies and materials, furniture and fixtures, cameras and lenses, and equipment for the office and studio.

It won't take long for you to get a feel for stocking office and photographic supplies and materials and to know what items you need to keep on hand. You'll want to place orders regularly but will probably find monthly to be too frequent. I try to order quarterly, because that keeps paperwork to a minimum and enables me to buy in money-saving quantities. Sometimes I buy more than a three-month supply to take advantage of sales.

Ask for Discounts

Unless you're already buying at rock-bottom prices, don't hesitate to ask your suppliers for better prices, especially local vendors and particularly if you buy in quantity. For example, you shouldn't have to pay a local photoshop proprietor the same price for photographic materials that the casual walk-in does. You represent volume buying and repeat business. It doesn't cost you anything to ask for a discount, but the savings may be great.

Buying Office Equipment and Supplies

When I started my business, I bought all my office supplies locally, but local vendors' prices eventually drove me out of town. Now I buy all office supplies by phone or online from direct sales outlets specializing in discounted office products, and I save an astounding amount of money each year (see the Source Directory under "Direct Sales Outlets: Business" and "Office Equipment and Supplies").

Buying Photographic Equipment and Supplies

Prices on photographic equipment and supplies often vary widely among different sources, even from day to day, so it pays to shop carefully. If you live in a major metropolitan area—such as New York, Chicago, Miami, Seattle, or Los Angeles—you have some big photographic outlets nearby and should have no trouble finding good prices on whatever you're shopping for. In smaller communities and for certain items, however, you might have to rely on direct sales outlets, where you place orders by phone, mail, fax, or online. Most of these outfits advertise heavily in *Popular Photography & Imaging* and other magazines, and you'll find full details on them in the Source Directory, under "Direct Sales Outlets: Photographic Equipment and Supplies" at the back of this book.

Mere listing of any company in the Source Directory is by no means an endorsement or recommendation. I have dealt with a number of them with generally satisfactory results, and I have listed no company with which I have had any major problems. I have found some of the best prices and consistently good service at Adorama, so that's where I buy most of my equipment and supplies. I can also recommend B&H Photo as a reliable source that offers good prices. When you deal with these or any other direct sales outlets, however, you should always compare prices, beware of pitfalls, ask plenty of questions, and adequately document all your orders. Be aware of the so-called gray market, which consists of photographic products not

meant for sale in the United States that, by one means or another, make their way to American shores and the inventories of direct sales outlets. Although equipment on the gray market is usually first-rate, it comes to the buyer without a U.S. warranty. It might have some sort of international warranty or a very limited dealer's warranty, either of which might well prove worthless. Gray-market equipment may come with manuals printed in a foreign language, and none of this gear is eligible for manufacturer rebates. Prices on such equipment are lower than U.S. warranty products, but such bargains are seldom worth the risk.

Be an educated consumer. Research before you invest in any high-ticket item such as a camera body, lens, or laptop computer. Even with smaller items, be aware of shipping costs and confirm if the products are in stock or on backorder. Always get a confirmation number for your orders and ask about the delivery method, cost, and time.

Ordering Online

Most companies now have Web sites, where you can learn about products you're interested in and place online orders. The best sites are easy to navigate, allow quick and simple order entry, provide competitive prices, instantaneously acknowledge orders by e-mail, and ship within one to three days. Many companies encourage customers to order online instead of by phone, because it's cheaper for them to process online orders electronically than pay employees to take telephone orders. The only way to order from amazon.com is online. They are reliable and offer a wide range of items. After an initial order and account setup, subsequent orders with amazon.com are simply a matter of quick and easy searches and following through with your order. Orders ship fast, often without shipping charges (always check).

Not all Web sites are created equal, however. They run the gamut from extremely valuable to totally useless and include everything in between. The good ones offer great service and products at the best prices and make online ordering fast and simple. The bad ones waste time and breed customer contempt.

Purchase Orders

Another form you'll use is the purchase order (PO). Although you won't need POs for local purchases, you will for many mail and phone orders. Printed forms are available at office-supply outlets and by mail or phone from Quill Corporation (see the Source Directory, under "Direct Sales Outlets: Business and Office Equipment and Supplies," at the back of this book). You can also use a computer and word-processing software to make your own forms, like the one shown on page 53.

PHOTO IMAGES UNLIMITED

1492 Columbus Drive ■ Moon Valley, IN 54321 ■ Phone: (123) 555–4545 ■ Fax: (123) 555–6767
E-mail: sallyjohn@homenet.com Web site: www.sallyjohnphoto.com

PURCHASE ORDER

TO: _____ Date _____

_____ Purchase Order # _____

_____ Customer Account _____

_____ Ship Via _____

	QUANTITY	ITEM NUMBER	ITEM DESCRIPTION	PRICE	AMOUNT
1					
2					
3					
4					
5					
6					
7					
8					
9					
10					
11					
12					
13					
14					
15					

Please include one copy of your invoice with the shipment of this order

PHOTO IMAGES UNLIMITED

1492 Columbus Drive ▪ **Moon Valley, IN 54321** ▪ **Phone: (123) 555–4545** ▪ **Fax: (123) 555–6767**
E-mail: sallyjohn@homenet.com **Web site: www.sallyjohnphoto.com**

PURCHASE ORDER

TO: *Wild Willy's Discount*
 Photo Supply
 77 West 13th Street
 New York, NY 10011

Date *August 15, 2010*
Purchase Order # *P-081510*
Customer Account *4321 0010 6541 9876* *Expires 8/12*
Ship Via *UPS Ground*

	QUANTITY	ITEM NUMBER	ITEM DESCRIPTION	PRICE	AMOUNT
1	2 boxes	EP-M100	Inkjet Paper Matte Finish 8.5x11	$10.95	$21.90
2	1 box/25 sheets	EP-EF25	Inkjet Paper, Exhibition Fiber 8.5x11	$38.95	$38.95
3	1 box/25 sheets	EP-EFB25	Inkjet Paper, Exhibition Fiber 13x19	$73.50	$73.50
4	1 each	SDMS8	8 gb Memory Card	$29.95	$29.95
5	1 each	SD4FW	CompactFlash Card Reader	$59.95	$59.95
6	2 packs	160NC	Portra NC 160-35 (5 per pack) Film	$23.45	$46.90
7	2 packs	400NC	Porta NC 400-35 (5 per pack) Film	$27.95	$55.90
8	10 each	TMX135-36	T-Max 100 B&W Film	$5.50	$55.00
9	10 each	TMY135-36	T-Max 400 B&W Film	$5.50	$55.00
10			TOTAL MERCHANDISE		$437.05
11			SHIPPING, HANDLING, INS		$35.00
12			TOTAL ORDER		$472.05
13					

Please include one copy of your invoice with the shipment of this order

The most obvious advantages of the purchase order are that it provides the vendor with a neat and organized customer order and gives you a record for follow-up. Even if you're ordering by phone, use a PO to keep everything straight and to create a record of the transaction. You needn't fill in all the blanks at the top of the form for phone orders, but at least note the company name and date.

Numbering Systems

Preprinted invoice and purchase-order forms come sequentially numbered or unnumbered. If you use unnumbered forms or forms you design yourself, you'll have to devise a numbering system. You can use a simple sequential numbering system, but you'll need to have a way to keep track of the last invoice or purchase order you sent, which can be troublesome. Whatever system you use or invent, make sure you never duplicate a number. In that way, each invoice and purchase order is specific and unique.

Some people prefer a numbering system that employs a six-digit date. It's easy to track, prevents duplication, and is easily modified to fit any situation. To distinguish invoice numbers from purchase-order numbers, prefix the invoice numbers with the letter *I* and purchase orders with the letter *P*. If you're sending more than one invoice or purchase order on any day, add a sequentially numbered suffix to each.

Had I used such a system when sending out a batch of invoices on August 16, 2010, here's how it would have worked. The six-digit date would have been 081610. The first invoice in the batch would have been numbered I-081610-1, the second I-081610-2, and so on. If I had sent but one purchase order that day, its number would have been P-081610.

This system is foolproof and couldn't be simpler.

Is the Lowest Price Always the Best Price?

If you can get the lowest prices and great service, as I do with Quill Corporation, that's the best of both worlds, but it rarely works out that way. You often have to sacrifice one for the other. But when it's a close call, give your business to a local company. Since you are starting a local business by working out of your home, it's beneficial to use local vendors whenever possible. This may help build your business, by building your reputation and sharing your services with others. Remember: Word of mouth can be your best advertising. It just may help build your business to pay a little more and have a connection to your community.

The Legal Aspects of Your Photography Business

Legal affairs are to the business side of photography what tripods and flash units are to the creative side: necessary accessories. Although your photography business isn't likely to become entangled in all the legal debris many businesses must contend with, there are legal matters you must consider. The first is to determine whether your business should be a sole proprietorship, partnership, or corporation.

Sole Proprietorship

Most of us who work out of our homes are classified as sole proprietors. That is, we are the only principals involved in the ownership and management of our businesses, and we are the only ones responsible for the outcome. We solely reap the benefits, pay the bills, and suffer the consequences of liability.

Even if you have other people working for or with you, you will probably remain the sole proprietor of your business. Having someone else working in your business in no way changes its status. You're not bound to that status forever, so you can always change later. Even if you eventually find partnership or incorporation advantageous, you will probably want to start out as a sole proprietor.

Advantages of Sole Proprietorship

On the plus side is simplicity. There's not much to setting up a sole proprietorship. You aren't encumbered with endless paperwork, and you don't need a lawyer to advise you or create documents for the operation of your business. You pay taxes via your personal return—Schedule C of Form 1040—and your tax rates will usually be lower than corporate rates.

Disadvantages of Sole Proprietorship

Among the disadvantages is difficulty in obtaining outside financing, especially during the start-up stage. You will be entirely responsible for any legal and financial problems your business encounters; therefore it carries the highest personal risk. Sole proprietors probably pay much more for health insurance than larger businesses do. A sole proprietor business is not transferable. You equal your business; when you die, so does the business.

Partnership

When two or more persons go into business together, they usually form some sort of partnership. Drafting a partnership agreement is advisable so that there are clear definitions of how the business will be conducted. Partners share profits, expenses, responsibilities, and liabilities. They might have equal divisions of the business or some other limited arrangement.

Partners enjoy the same tax breaks as sole proprietors. Each reports business profit and loss on Schedule C of Form 1040. It's fairly easy to set up a partnership, and doing so doesn't cost much in the way of attorney's fees.

Advantages of Partnership

Among the advantages of partnership for home-based photographers is the division of major equipment costs. For example, one partner might be responsible for setting up and equipping a digital darkroom, while the other would see to studio needs. The two then work out agreeable schedules for the use of these facilities.

Sharing costs and use of many high-ticket items makes sense, seeing as such equipment often stands idle much of the time. Photographic partners can share computer hardware and software, expensive copying and duplicating equipment, projection systems, costly lenses, and much more.

The sharing of labor and brain power can lead to the landing of big jobs and contracts the lone photographer might not be equipped to handle. So partnership can foster many commercial, industrial, and governmental opportunities.

Disadvantages of Partnership

Partnerships face the same financial difficulties and liabilities as sole proprietorships. Division of management responsibilities can lead to disagreements. And there are always potential problems awaiting the day when a partner leaves the business,

for whatever reason. The partnership dissolves with the withdrawal or death of a partner—this needs to be addressed in the partnership agreement.

Those considering partnership must breach numerous obstacles and work out many potential problems. Will the business operate out of one home or both? If one, which one? Will partners carry equal workloads? How will they measure work? Will investments be equal?

Partnership Agreement

Any partnership requires a good written agreement. The better and more complete the agreement, the fewer the hassles down the line. Partners should spend time, individually and together, considering, discussing, and writing down everything pertaining to the business and partnership. Set everything you can think of in writing.

When you decide on an attorney, give that attorney a copy of the document you and your partner or partners have created, and set up a later meeting date. Your attorney should then draft an agreement for approval of all parties. After corrections, additions, and deletions, the attorney will draft the final agreement for partners' signatures.

The agreement should make provisions for division of expenditures, profits, losses, responsibilities, and liabilities, as well as prolonged illness, disability, or death of a partner. You must also consider the disposition of the share of a partner who retires from the business or leaves for any other reason. Include a buyout clause, and have your attorney advise you on restrictions pertaining to buying and selling of the business or any partner's share. You may want to include nondisclosure and noncompetition clauses.

The agreement can be revised or amended at any time, and it should be whenever the partners make major changes in the way the business is operated. Put it in writing, and keep it current.

Limited Liability Company

A limited liability company (LLC) is a partnership that enjoys some of the advantages usually restricted to corporations. LLCs are relatively new options for businesses. In the last twenty years they have been used more in small businesses. If you're thinking about forming a partnership, ask your attorney about the possibility and advantages of forming an LLC within your state. The LLC allows for multiple owners or members. However, if the LLC has just one owner, it will be taxed as a sole proprietorship.

Advantages of Limited Liability Companies

An LLC is reasonably easy to form with the assistance of an attorney. There is relative low personal risk with an LLC. The main advantage is that it shelters your personal liability from your professional liability. This could be an alternative to a sole proprietor structure.

Disadvantages of Limited Liability Companies

The LLC model is a relatively new business formation and not well understood. Your overall legal bills may be higher, considering it requires more involvement with your attorney to draft legal agreements. It is best to consult your attorney to see what your state allows and then weigh your options before making a final decision.

Corporation

It's highly unlikely that you will want to consider incorporating when you start your business; in fact, you may never wish to incorporate. In the event your circumstances change, however, you should know something about the pros and cons of incorporating. A good attorney and accountant will be able to advise you on this major step.

Incorporation can be expensive. You will need an attorney's help, and you may have to pay a state fee of $1,000 or more.

In a sole proprietorship or partnership, the principals are the business, and vice versa; everything that affects the business affects the owners. A corporation is an entity in and of itself.

Advantages of Incorporation

In a corporation, shareholders' assets are protected and corporate assets are initially protected by current bankruptcy laws. Depending on the type of business, corporations generally find financing more readily available than sole proprietorships and partnerships do.

Disadvantages of Incorporation

On the downside, corporations are much more complicated and expensive to set up. Most pay high corporate tax rates. In general, a corporation faces more complications, with requirements for bylaws, a board of directors, corporate officers, annual meetings, and greater need for attorneys and accountants.

Zoning Ordinances

Municipalities and counties throughout the nation create urban and rural zones to allow, prohibit, promote, or discourage various activities. Certain areas and neighborhoods might be zoned agricultural, industrial, light industrial, heavy industrial, commercial, residential, and even such combinations as multiresidential or commercial-residential.

In some residential neighborhoods all business is prohibited, no matter what form it takes. Such restrictive zoning, however, is rare.

Obviously, you'll have no problem running your business in any industrial, commercial, or commercial-residential zone. Nor will county officials give you any trouble about operating in an agricultural zone.

Restrictive zoning of most residential neighborhoods is aimed at businesses that create noise, pollution, heavy traffic, and other activities best confined to industrial and commercial zones. Many allow professional and service businesses to operate, so you probably won't have any opposition to your running a home-based photography business. You need to be sure, though, so you'll have to check. You will also need to look into your city or town requirements before you hang a sign in front of your home for your business. Here, again, your local Small Business Development Center should be able to help. You can also check at city hall or county offices.

Naming and Licensing Your Business

Your business must have a name, but it needn't be any more than your own name. It can be your name or part of your name with or without other elements, or it can be entirely made up, with no reference to your name.

If you have already decided on a business name—your own or an assumed, or fictitious, name—you need only determine what your legal requirements are and how you should go about fulfilling them. If you're undecided on a name, make a list of potential names and spend time with the list before making a final decision. You can also do a search on google.com to look up any potential business names and see if anyone has already used your idea.

Let's take a look at how such a list might help someone named Sally John, who is trying to name her home-based photography business. Here are some possible combinations:

1. Sally John

2. Sally John Photography

3. Sally John Photo Studio

4. Sally John Portrait Studio

5. S. John Photography

6. Photos by Sally John

7. SJ Photo

8. SJ Photography

9. Sally John Images

10. SJ Images

List all the names that appeal to you and then start to eliminate those that do not work. This is a good exercise in coming up with a name for your business. You may want to do this along with purchasing a domain name for your Web site (see Chapter 10, "Marketing Your Photography Business") so that you can coordinate your business name with your Web site address.

Registering Your Business Name

Before choosing a name for your business, you'll need to learn about any legal restrictions. Depending on state law or local ordinances, you may or may not have to register your business name; even if you're not required to do so, you may want to. Visit your local Small Business Development Center or chamber of commerce and ask for information about registering a business name. Once your name is registered as a business, you may have to pay an additional tax for running a business in your town or city.

Mistakes to Avoid

In naming your business, avoid vogue words, slang, and clichés. Don't be too cute. There's nothing wrong with a good catchy name, but a fine line divides catchy business names from cutesy ones.

Stay away from names that are too obscure or esoteric for the general public, or any that are otherwise inappropriate. You want your business name to be

remembered. It should be easy to say and easy to spell. Don't let your business name limit you. Try not to be too specific with the name—for example, John Portrait Studio. This is a good name, but may be too limiting if John would like to branch out in other areas of photography besides portraiture. Photography is a broad field, and for most home-based businesses, reference to photography in the name should provide the necessary information and diversity.

Licenses and Permits

When you visit the Small Business Development Center or local governmental offices, inquire about any requirements for licenses or permits. You might need some kind of paper issued by the state, county, or city you live in.

There's usually a small annual fee associated with business licenses or permits. Failing to be properly licensed, however, could cost you a stiff fine or even put you out of business.

Hiring an Attorney

It is beneficial for you to have access to a good lawyer that is knowledgeable in business practices.

Do You Need a Lawyer?

The important question is, do *you* need a lawyer? And the simple answer is, probably. Chances are you will need one at some point in your adventure as a business owner. Do you need one right now? Probably not, but you should keep one handy. That means you must find a lawyer with a good reputation, make an appointment, and discuss your plans. There should be no charge for this initial meeting, and you should feel no obligation toward the lawyer or law firm. If, for any reason, you're uncomfortable or uneasy with this lawyer, try another. In fact, you might want to meet with several before deciding on which one would be ideal as your legal adviser.

Finding the Right Lawyer

The best way to locate prospective lawyers is to ask around. If you know other photographers and entrepreneurs in your community, ask who their lawyers are and if they're satisfied with the service they're getting.

Your state bar association might have a referral service. Many lawyers specialize, so you can narrow your choices by eliminating those prospects who work primarily

in areas irrelevant to your needs, such as probate, divorce, juvenile, mortgage, immigration, bankruptcy, or personal-injury law. Look, instead, for a lawyer with a general practice and experience in contract and business law. The same lawyer will probably be able to handle your personal legal matters as well. Should the need for a specialist arise—say, for someone versed in copyright law—your attorney will probably be able to refer you to a competent colleague.

Insuring Your Home-Based Business

An insurance agent should be more than someone who peddles policies and collects commissions, so you will have to shop around for the right agency and insurance companies.

I use the plural *companies* because you will need several policies and might have to deal with more than one company. Independent agents, however, write policies for various companies, so it's possible to work with one agent for all your insurance needs. In any case, you should review your insurance requirements and policies annually and compare prices.

Will Your Homeowner's Policy Suffice?

Your homeowner's or renter's policy may or may not cover your business. That's the first thing to find out. Even if it does, there may be limits to the coverage on some expensive equipment. For example, cameras and lenses might be covered, but only for a few hundred dollars. So you will want to list certain items and get additional coverage for them. You may need a rider on your policy to cover your business as well as your home and all its contents.

Scheduling Equipment for All-Risk Coverage

I travel a good bit and always have with me camera gear worth several thousand dollars. I'm also frequently on the water, boating or canoeing with photographic gear along. I not only have all such equipment listed but also carry replacement-value, all-risk coverage on it. So it's covered on and off my property against theft or loss for any reason.

The list I provided to my insurance agent shows every camera, camera body, lens, motor drive, electronic-flash unit, tripod, exposure meter, and other expensive equipment, with serial number and current replacement value. I also list "filters and lens attachments" as one item and "miscellaneous" as another, each with a

replacement value. I have the list on a computer disk, so it's easy for me to send a revision to my agent whenever I buy, sell, or trade in a piece of equipment.

Vehicle Insurance

There was a time when most of us took out a vehicle policy and stayed with the same company permanently. Policies were nearly identical, and rates were similar. Not so now. Rates and coverage can vary considerably from company to company. So look around, and remain alert for better deals. Always make sure you are current with your policy and have an up-to-date car insurance card in your vehicle.

Do You Need Extra Liability Insurance?

Liability insurance is expensive, and that included in your homeowner's or renter's policy may not be adequate for your business. If you specialize in portrait photography or any other field that will have customers or clients coming to your property, you'll probably need extra liability coverage, so discuss that with your agent.

Disability and Health Insurance

If you're young and healthy, you should probably consider disability insurance. The older you get, and the more health problems you have, however, the higher the premiums will be. In fact, they quickly rise to prohibitive levels.

Conversely, the younger and healthier you are, the cheaper your health insurance will be. No matter your age or condition, though, as a self-employed person you can count on paying the highest premiums. Some professional associations offer group rates for their members. Also check with the Small Business Association to see if they have any information on health insurance options. There are so many changes occurring in this area, you must do your research to find what policy would work the best for you. In the meantime, take good care of yourself and get plenty of rest as you work through these decisions.

Life Insurance

Life insurance is a complicated matter about which few generalizations are possible. You must assess your own situation to determine what kind of coverage, if any, you will want or need. If your death and the loss of income from your photography business would create financial hardship for anyone, you probably need some kind of life-insurance policy, either term or whole life. Talk to your agent about it.

Finding an Insurance Agent

Find an insurance agent the way you would find an attorney or accountant. Ask others for recommendations. Talk to several agents, and pick the one who seems to know the most about the insurance business and can assure you of looking out for your best interests.

Copyright

Copyright is a form of protection for original works that authors, poets, playwrights, composers, choreographers, artists, photographers, and other creators enjoy. It is afforded more or less automatically to any work, immediately on its creation in fixed form, and the copyright on the work normally becomes the property of the author or creator. The Copyright Act is a federal law, not a state law; therefore the law is consistent across the United States.

Registering Copyright

Filling out a form and paying the necessary fee to the U.S. Copyright Office does not copyright a work. Copyright is part and parcel of the creation process. If you create a work in fixed form, it is copyrighted and you own the copyright, unless you were an employee of a company and that company paid you to create the work, or you were not an employee but created the work under the terms of a work-for-hire agreement. Filing the paperwork and paying the fee registers the copyright.

There is no requirement to register a copyright, but it's best to do so as a way of claiming your copyright. Registration helps immensely if you ever need to sue someone for copyright infringement.

Material That Can Be Copyrighted

Copyright is available for unpublished and published works. It protects all unpublished works. It protects virtually all published works created by United States citizens and most foreign residents in the United States, as well as citizens of foreign nations that are signatories of one of the various copyright treaties to which the United States is also a party.

Among the various kinds of copyright-protected works, those you are most likely to create, use, or come in contact with in your business are literary works, photographs, digital images, graphic works, maps, and computer software.

Material That Cannot Be Copyrighted

Some material is not eligible for copyright, such as ideas, procedures, principles, names, titles, slogans, short phrases, lettering, familiar symbols, and typographic ornamentation. Most government-prepared material is also public domain and cannot be copyrighted.

Ownership and Rights

Mere ownership of a work does not grant copyright to or imply copyright by the owner. Unless otherwise agreed upon in writing, copyright belongs to the creator of the work. For example, if you sell someone a matted and framed display print, the person who buys it indeed owns that print and may keep or dispose of it in any way, including selling it for a profit. But that person may not legally copy or reproduce the print in any way without your written consent. You retain the copyright and may produce and sell as many duplicates as you wish unless the print is part of a limited-edition run.

Similarly, when you sell a photograph for publication—in a newspaper, magazine, book, calendar, greeting card, or postcard or in any other medium—you actually sell not the photograph but rather the right to use that photograph for a specific purpose. Usually the right is for one-time use only, unless otherwise specified. You retain ownership of the photograph, copyright, and all residual and subsidiary rights.

Publication with Proper Notice

Before 1978, to be copyrighted most works had to be published with an acceptable copyright notice. Although virtually all works, published or not, are now protected, publication with the proper copyright notice is still important.

The Copyright Office defines publication as "the distribution of copies . . . of a work to the public by sale or other transfer of ownership, or by rental, lease, or lending." Publication photography is not the only area where you need to concern yourself with copyright matters. If you sell salon or display prints through art galleries or at art exhibits and craft shows, you are effectively publishing your work, and it should bear proper copyright notice. Copies of your work appearing as posters, postcards, greeting cards, T-shirt images, and fine-art prints should bear your copyright, as should any of your photographs appearing in any noncopyrighted publication.

As of March 1, 1989, use of the copyright notice became optional; before then it was mandatory. I recommend you follow the practice, however, because it offers

certain distinct advantages. A copyright notice shows the year of first publication, which is an important reference. It identifies you as the owner of the copyright, and it serves notice to the public that the work is protected.

Most important, if the copyright is infringed but the work carried the proper notice, the court will not allow a defendant to claim ignorance. Damages awarded might go as high as $10,000 per infringement and in some cases could be up to $100,000 plus attorney fees and court costs. You may successfully sue for infringement even if the work did not bear copyright notice, but the claim can be deemed "innocent infringement" and result in greatly reduced damages, perhaps as little as $100.

A proper copyright notice has three important elements: (1) the copyright symbol ©, or the word *Copyright,* or the abbreviation *Copyr.;* (2) the year of first publication; and (3) the copyright owner's name. For example: Copyright 2010 by Kenn Oberrecht.

How Long Does a Copyright Last?

Any work copyrighted on or after January 1, 1978, is protected for a period consisting of the author's or creator's life, plus seventy years. Any work created but not published before January 1, 1978, is now afforded the same protection.

For additional information on copyright, visit your local public library. The Copyright Office will also send you a packet of publications on copyright, as well as the proper forms and instructions for registering copyright. You can also access and download material at the Copyright Office's Web site (see address in the Source Directory, under "U.S. Government," at the back of this book).

Contracts

A contract is an enforceable agreement between or among two or more parties, permitting or prohibiting certain actions and activities, with mutual but not always equal benefits accruing to each party. Contracts of some form or another are used in most businesses.

Professional photographers use various kinds of contracts in their work: publishing agreements, agency agreements, transfer-of-rights agreements, work-for-hire agreements, model releases, and work orders, among others. You might use any or all of these, depending on the nature of your work.

Transfer-of-Rights and Work-for-Hire Agreements

If you work as a publication photographer, you will be required to sign contracts usually generated by the publishers. These are commonly transfer-of-rights agreements that specify the rights you are granting. Some publishers, whose interpretation of the letter and intent of the copyright statutes is extremely broad, use work-for-hire agreements instead. These effectively force you to give up all rights in and ownership of the work.

Some publishers' transfer-of-rights agreements stipulate that the purchase is for all rights or world rights, which, of course, leaves the photographer without any future rights to use the work. I suggest you adopt the policy of selling only one-time publication rights to any photograph. If a publisher insists on buying all rights or using a work-for-hire agreement, either decline or insist on much higher payment than you might get for one-time use.

Keep in mind that a single transparency, negative, print, or digital image might generate numerous sales for years to come. Many professional photographers have photographs on file that have sold over and over again and earned thousands of dollars. You relinquish that potential whenever you agree to sell all rights to a photograph or sign a work-for-hire agreement.

Don't be intimidated by all the legalese contained in a transfer-of-rights agreement that calls for all rights. Before you sign any contract, make sure you understand all aspects of the agreement, ask questions, and don't back down if you are feeling intimidated. You must stand up for your rights and demand fair payment for your work at all times.

Agency Agreements

If you plan to work with a stock agency, you will be asked to sign an agency agreement, which stipulates that for each sale the agency makes, you and the agency split the payment received, usually fifty-fifty, but sometimes better, such as sixty-forty, photographer's favor.

Get Help

If you aren't accustomed to working with contracts and you find their language baffling and full of obfuscation, note the confusing and confounding clauses. Then take the contract and your notes to your attorney for a translation. Pay close attention

to what your attorney tells you, and soon you will learn to comprehend contracts without having to pay someone to interpret them for you.

Model Releases

Another common contract photographers use is the model release. A model release is a short and simple agreement between photographer and model, in which the model signs over the rights to the photographer to use the model's photographic image free of encumbrances.

Model releases are required for all photographs with recognizable images of people when used in advertising, sales brochures, catalogs, and many company-sponsored magazines and other publications. Although model releases aren't generally required for photographs used editorially or to illustrate text or editorial copy in books and periodicals, some publishers require them. Moreover, it's a good idea to develop the habit of using them, not only to protect yourself from any potential lawsuit but also to make your photographs as widely salable as possible.

A photographer friend of mine on a Montana ski trip spent a good bit of his weekend shooting photos for calendars, magazines, and other markets. A magazine bought one-time rights to one of his photographs of three beautiful young women, colorfully clad in ski outfits. Soon after the photograph ran, a ski manufacturer phoned to buy rights to the photograph for many times what the magazine had paid. It turned out that the manufacturer's name clearly appeared on all the skis in the picture. My friend, however, had failed to get his models to sign releases, so there was no sale. You can bet he hasn't made that mistake again.

You needn't worry about model releases for photographs in which people are unrecognizable. If a person is clearly recognizable, however, get a release. Of course, if you're hiring a model for a shoot, a model release should be part of the working contract. When you travel, carry a supply of model releases with you, and use them. You'll find that most people will be thrilled that you want to use their images for publication, and they'll gladly sign your releases.

In contract language, valuable consideration simply means money. When you hire a professional model, you will agree on payment before the shoot. When you ask nonprofessionals to sign model releases, most will do it for free. In either case, offer the models prints or final copies of the published photographs. This is good business practice.

SALLY JOHN, PHOTOGRAPHER

1492 Columbus Drive • Moon Valley, IN 54321 • (123) 555–4545

MODEL RELEASE

DATE: _____ FILE REF: _____

For valuable consideration received, which I hereby acknowledge, I irrevocably grant Sally John, and anyone Sally John authorizes, the absolute permission to use, reproduce, sell, and resell any pictures of me, or any in which I may appear, in whole or in part, taken this day, and to be used for publishing, advertising, art, trade, or any other lawful purpose.

I hereby waive any right to inspect or approve these pictures or any captions or text that may be used in connection with them, or to approve the use to which such material may be applied.

I hereby release Sally John and any of Sally John's heirs, executors, administrators, associates, and assigns from liability for any blurring, distortion, alteration, or optical illusion, whether intentional or not, that may result from the making of these pictures.

I am 18 or older: YES _____ NO _____ (Under 18, see section below)

Model's Name (print) _____ Phone _____
Address _____
City _____ State _____ Zip _____
Model (sign) _____
Witness (sign) _____

FOR ANY MODEL UNDER 18 YEARS OF AGE

I hereby certify that I am the parent or legal guardian of the above-named model, and I consent, without reservations, to all the foregoing on behalf of the model.

Parent/Guardian (sign) _____
Witness (sign) _____
Date _____

Property Releases

You may consider having a property release signed if you are photographing some-one's property that is recognizable and will be published for public viewing. This is important for architectural photography, especially if you are considering using the photos for any other purpose, such as a promotional piece for your business. As with other releases, the property release should be signed at the time the property is used. And payment should be offered to the owner of the property.

Other Contracts

Some photographers use work orders or job orders to set up contracts with their customers. These are simple forms that you fill in with all the pertinent information and customer's stipulations. The form should be imprinted with your conditions and stipulations. When the customer signs the order and receives a copy of it, you and the customer then have a contract for a specific job.

You can have a local printer print work orders and other contract forms, make your own forms, or order them by mail. NEBS, Inc., has a number of such forms available for photographers that the company will imprint with your name, address, and phone number. (The NEBS address is listed in the Source Directory, under " Direct Sales Outlets: Business and Office Equipment and Supplies," at the back of this book.) Among NEBS's offerings are a wedding-photography contract, a video contract, and a general-photography contract that covers most jobs. The company will also custom-print contract forms for you.

06

Writing a Business Plan

A business plan is your blueprint for success. It's not something you devise and abandon once you're in business. It's a working, changing, growing document, the basis for all your future forecasting and goal setting. If you want your home-based business to succeed, you must plan for its success.

A business plan is a detailed scheme describing how a proposed or existing proprietorship, partnership, LLC, or corporation conducts its operations. It's a strategy you work out in advance, designed to define the ways you will finance, operate, and profit from this service-oriented business.

Your business plan can also be a document to use for attracting financial backing or selling your services to potential clients. Moreover, it can help you establish credit and credibility.

Drafting a business plan requires careful thought, effort, and time. Don't try dashing it off over a weekend. Take the task seriously, and give it the time it needs.

When I started my business, I did not have a written business plan. I had a good idea of what I wanted to do and how I intended to accomplish it. I'm not sure a written plan would have made a great difference in the early, part-time years of my business. Nevertheless, I'm convinced that a formal plan would have forced me to consider aspects of the business I had ignored and would have alerted me to potential problems I could have averted.

For most prospective entrepreneurs, the toughest part of writing a business plan is getting started. If you've read the first five chapters of this book and followed the directions there, you have already begun putting your plans and ideas on paper, and you should realize by now that it's not such a difficult process.

Writing a business plan is a challenge, but it can be an enjoyable and enlightening exercise that hones your problem-solving skills and provides a foundation to build your business on.

Why You Should Write a Business Plan

A business plan is a way for you to bridge the gap between your vision and the practical articulation of your business. It is a tool to assist you in mapping out your vision. One of the most important reasons for a business plan is to prove your concept on paper and create a guide for the initial stages of your business. As your business develops, so will your business plan.

Your reasons for developing a good plan are more fundamental and pragmatic. Your plan should enable you to do the following:

- *Assess the feasibility of the venture.* You will eventually have to convince others that your home-based photography business is or will be a healthy, viable operation. The first person you must convince, though, is you. A good business plan is the most persuasive tool at your disposal for that purpose. Ultimately, you'll be able to determine whether you should start your own business or keep your day job.
- *Evaluate business resources.* Listing all your physical assets and professional attributes allows you to determine where your needs lie and what your strengths and weaknesses are. This can serve to reassure you and others and to steer you down the right road.
- *Evaluate financial resources.* Before going into business, you must know what your financial status is and where you'll acquire needed operating capital. You should also have something to fall back on in case of an emergency or something to count on in the event of an investment opportunity.
- *Identify potential clients.* You must know who your clients or customers will be in order to effectively market your services and products to them. You need to identify your immediate buyers and target your future buyers.
- *Establish a workable timetable.* Once you have determined that your venture is feasible and have evaluated your resources and markets, all that's left is to decide when to open your business. You should also make some flexible decisions about growth and progress by plugging future plans into your timetable.

- *Set reasonable and competitive fees or prices.* How will you bill your clients or charge your customers? What do other local photographers charge? You'll need to thoroughly research fee and price structure to ascertain what your services and products are worth and include that information in your business plan.

- *Provide a framework for scheduling.* Time study and scheduling are crucial to business success. You must know not only what any given project or product will cost you to produce but also how much time it will take. Both short-range and long-range scheduling will continue as an integral, ongoing process for the life of your business.

- *Create a basis for forecasting.* Related to the scheduling process is a form of guessing known as forecasting. Forecasting business trends, cash flow, and profit margins requires intelligence, experience, a thorough understanding of the competition, and a firm grasp of markets.

- *Facilitate the setting of realistic goals.* A business without goals is a trip without a destination. It's important to set goals from the start and, as you realize them, to set new ones. Your goals shouldn't be too easily attained or impossible to achieve. They must be on the tough side of realistic.

- *Land important and lucrative jobs.* If you have an opportunity to bid on a corporate or government job, the people letting the contract will want to know all about you and your business.

- *Secure bank or investor financing.* Although it's best to avoid borrowing money to run your business—especially during the formative years—you might experience a temporary cash-flow interruption or may need to buy some expensive equipment in order to land a job. A business plan can go a long way toward securing needed funds.

Tips for Preparing Your Business Plan

No rules or formulas exist for preparing a business plan. Just as no two businesses are entirely alike, no two plans can be identical. Business plans vary greatly, even within the same industry.

There's no set length or established format for a business plan. It can be as detailed or abbreviated as you want to make it. Business plans for major companies might run to forty pages or more. Yours will certainly be shorter—probably

something between ten and twenty pages. But don't consider this absolute. Make it whatever length you're comfortable with.

As you begin listing information for your plan, include as many details as you can. Make the rough draft as long as it needs to be. Then edit it down to as precise and concise a document as possible.

Remember: A business plan is a working document that is about your operations; it should change as your business does. Consequently, this is not something that simply amounts to filling in the blanks on a form.

Business-plan forms are indeed available from several sources. You'll find them in books on business and publications from the Small Business Administration, as well as in handouts from a local Small Business Development Center. All of these—including this chapter—are only guidelines, designed to help you write your own business plan.

The following are some helpful hints on preparing your business plan.

- *Start with an executive summary.* Other important sections should address such topics as organization, finances, management, and marketing.
- Divide your plan into sections. Title each section according to its contents: Executive Summary, the Organizational Plan, the Financial Plan, and so on. Divide the sections with subheads. Include a table of contents and use chapter separators for ease in finding each section.
- *Include appendices.* The appendices should include ancillary documents that back up information you would like to share to support your plan, such as your résumé, credit references, letters of recommendation, and additional financial data.
- *Write your plan yourself.* If you need to use an editor to assist you with your writing skills, make sure your business plan is in your voice, not theirs.
- *Use visuals!* You are writing a plan for a photography business, so add some photos. Have a dynamic color photo on the cover of your plan, and then enhance the plan with a few visuals to help articulate your vision.
- *Make your plan interesting.* You have only a minute or two to capture your reader, especially if you are presenting the plan to a potential investor.
- *Avoid jargon, clichés, and buzzwords.* Don't try to impress people with big or fancy words or with how much you happen to know about business or photography. Keep the language clear, simple, and straightforward.

- *Have someone else read your plan.* Even if you are a skilled writer who doesn't need outside help, have someone read your plan and look for those elusive typographical errors and the little obscurities that make a sentence or paragraph cumbersome or awkward. Your plan should be pleasantly readable.
- *Give your final plan a professional look.* Be sure it is neatly typed and printed. A color cover with a photograph is a good start. Have your plan printed into a spiral- or comb-bound (lays flat when open) presentation. Make sure everything about your business plan is as perfect and readable as you can make it.

Cover Page

Center the phrase *Confidential Business Plan* at the top and bottom of the cover page, preferably in large boldface type. This is a message to anyone who reads or refers to your plan that the contents are not for general distribution.

About a third of the way down the page, center your business name, street address, P.O. box if you have one, phone number, fax number, e-mail address, and Web address if you have a site.

Then number each copy you distribute, for whatever reason. Keep a log in your business-plan file that lists every person who receives a copy of your plan, the number on that copy, and the date of distribution. This is another important message to anyone in possession of your business plan. It lets people know that you are keeping tight control of this document and implies that the recipient has the responsibility to safeguard its contents.

Table of Contents

Provide a table of contents as a convenience to the reader. Simply list the various sections of your plan and their corresponding page numbers.

Executive Summary

Like the table of contents, the executive summary is provided as a convenience for the reader. Your business plan covers all aspects of your business in detail. The executive summary is essentially a two- to three-page short story about your business. Try to distill the essence of your business in these pages, with perhaps a paragraph each devoted to the major sections of your business plan.

CONFIDENTIAL BUSINESS PLAN

Photo Images Unlimited

1492 Columbus Drive

Moon Valley, IN 54321

Phone: (123) 555–4545

Fax: (123) 555–6767

E-mail: sallyjohn@homenet.com

Web: www.sallyjohnphoto.com

Proprietor: Sally John

Copy Number _____

CONFIDENTIAL BUSINESS PLAN

The executive summary is a courtesy to anyone who will be reading or referring to your business plan. In the minute or so it takes to read this section, you want to capture your reader's interest and attention. That makes the executive summary an extremely important part of your business plan.

Like the lead to a magazine article or news story, the executive summary must be as interesting, informative, and relevant as you can make it.

The Organizational Plan

Here's where you lay out the specifics of your business organization. Start by identifying yourself and your business as a sole proprietorship, partnership, LLC, or corporation. Your home-based photography business will doubtless begin as a sole proprietorship, and chances are, it will remain in that status.

If you have one or more persons working with or for you, include that information. Tell whether these are full-time, part-time, permanent, or temporary employees or associates. Discuss their contributions to the operation of your business. If they're family members, mention that, too.

You need to indicate why your business exists and how it functions. Discuss its strengths, your business philosophies, and your photographic skills. Resist any temptation to get technical.

Provide a clear picture of where you stand as you plan to launch your business and where you *intend* (don't use the word *hope*) to be a year from now, two years from now, and five years out. Demonstrate that you have immediate objectives and long-range goals. Write about the scope and direction of your business, and tell what your scheduled operating hours and days are.

The Financial Plan

This is the most important part of your business plan. That's why two chapters in this book are devoted to financial planning and management. If you have read Chapters 3 and 4 and prepared the financial documents covered there, you have already done most of the work required for this section of the business plan.

Statement of Financial Condition

Begin the section with a brief narrative statement of your financial situation, followed by a statement of financial condition, also known as a personal financial statement or statement of net worth. (See the section in Chapter 3 on "The Personal Financial Statement.")

For the beginning entrepreneur, this is the only part of the financial plan that can be precise. The rest of it is an educated guess at best, but you'll be called on to make such guesses more often than you might think, especially by lending institutions, the Internal Revenue Service, and perhaps your state revenue agency.

Sources of Funds

Here is where you divulge your financial sources. You can't expect to attract clients or customers if you haven't carefully and wisely invested in assets and made plans to capitalize your business. What's more, investment and capitalization are continuing processes, lasting as long as you remain in business.

The chief function of a business plan is to provide an accurate appraisal of your business's financial health. This is not just so you can secure loans or entice financial backers; it should also make financial management easier for you.

Include a short report in your business plan called "Sources of Funds," which should list your assets, their worth, and their sources, as shown in the accompanying sample.

The "Capital Assets Inventory" form is handy for compiling the figures you'll need. Use a separate form for each type of property listed: furniture and fixtures, office equipment including all computers used for your business, darkroom equipment (if applicable), studio equipment, and photography equipment. You need not include these forms in your business plan, because you'll summarize their contents under "Sources of Funds."

The completed inventory forms, stored with your insurance policies, are valuable documents should you ever experience a casualty loss, so it's important to update them regularly. If you carry all-risk coverage for your photography equipment, be sure to send a copy of the appropriate form to your insurance agent each time you update it.

Profit-and-Loss Projection

For purposes of your business plan, prepare a profit-and-loss projection for the upcoming year on a monthly basis, then quarterly for the second year, and annually for the third, fourth, and fifth years. (See details in Chapter 3, "Financial Planning.")

Remember: A business plan is a living, working, evolving document. It should be a five-year plan that you review and modify as necessary—at least once a year.

Sources of Funds

ASSETS	AMOUNT/COST	SOURCES
Cash	$3,000	Business Savings
Investments	$15,000	Certificates of Deposit
Accounts Receivable	$2,000	Business Sales
Materials and Supplies	$1,500	Currently on Hand
Vehicle	$14,000/$17,500	Installment Purchase
Furniture and Fixtures	$1,300	Currently Owned
Office Equipment	$2,200	Currently Owned
Darkroom Equipment	$800	Currently Owned
Studio Equipment	$400	Currently Owned
Photography Equipment	$3,600	Currently Owned

Balance Sheet

People accustomed to working with balance sheets will no doubt want to see one in your business plan. Prepare one according to the directions in Chapter 3, "Financial Planning."

Cash-Flow Projection

A cash-flow projection will probably prove to be one of your more useful financial documents, so you should include one as part of your business plan. (See details in Chapter 3, "Financial Planning.") You might also want to discuss how you can use profit-and-loss and cash-flow projections to manage the financial aspects of your business.

The Management Plan

In this section you must demonstrate your ability to manage your operation. Various business publications stress the importance of the team concept of management. They insist you list the members of your management team and devote a half-page each to a description of each member's strengths and management experience.

Type of property _____ Date of Inventory _____

DESCRIPTION	SERIAL NUMBER	DATE ACQUIRED	COST OR VALUE
TOTAL VALUE			

Type of property _Photography Equipment_ Date of Inventory _August 1, 2010_

DESCRIPTION	SERIAL NUMBER	DATE ACQUIRED	COST OR VALUE
Nikon D300 Body Only	455378	2009	$1,800
Olympus Camedia C-720	107057840	2003	$350
Nikon N90 Black Body	3136759	2008	$900
Nikon 14-24mm f/2.8 Lens	2864701	2009	$1,800
Nikon 18-105mm f/3.5 AF-SZOOM	2302506	2008	$350
Nikon 70-300mm f/5.6 Zoom Lens	2229816	2008	$150
Nikon 55mm f/2.8 Macro Lens	357990	2008	$450
Tamrac System Pro Series Bag		2010	$140
Tamrac Digital Zoom Pack		2010	$65
Tamrac Photogrpher's Daypack		2005	$80
Slik Tripod		2006	$110
Filters, Flashes, and Accessories			$700
TOTAL VALUE			$6,895

Who Are the Players?

In your home-based photography business, you probably represent the entire management staff and labor force. Here is where you will share your vast experience and diverse skills.

Talk up your abilities and tell how your business will profit from your talents. I'm not suggesting you embellish the facts; merely uncover them and use them to your best advantage. If you have team members, you will need to include their information in the plan, emphasizing the skills and knowledge they bring to the overall continued success of the business. Be concise and organized.

Discuss Your Skills and Experience

In courses I've taught, I have worked with students who think they have no valuable experience to lean on, nothing worthwhile to offer. A brief one-on-one conference or interview, however, invariably turns up hidden talents and attributes.

To help you prepare a brief narrative statement, refer to your résumé, or make a list of the jobs you've held and duties you were responsible for. Be relevant. Zero in on jobs and duties that demonstrate management skills.

For instance, if when you were a high-school or college student the state highway department hired you in the summer to pick up roadside litter, that's not relevant. On the other hand, if you were put in charge of a crew of summer workers picking up litter, that shows you have supervisory experience and indicates you can handle responsibility.

If you have photography experience, describe that too. Include amateur as well as professional work. Tell about any awards, exhibits, or special recognition you've had.

You should even include any relevant volunteer or pro bono work and organizational offices you've held. All of this contributes to your business and personal identity and defines who and what you are.

List Your Business Associates

Even if you are the sole proprietor of a one-person operation, you have or should have professional or business associates you should list in your business plan. Provide the name, address, and phone number of your insurance agent, banker, accountant, and lawyer, as well as any photo labs you work with.

Deal Intelligently with Your Weaknesses

Of course, you'll want to elaborate on your strengths as a manager and photographer, but you should also identify your weaknesses and describe the actions you'll take to eliminate them.

Weaknesses and insufficiencies are nothing to be ashamed of, but if you ignore them or fail to plan for their elimination, they remain an impediment to progress and success. Merely planning sensibly to shore up a weakness can neutralize its effect for the time being. Taking action as planned can turn a weakness into a strength.

The Marketing Plan

The first step in drafting a marketing plan is determining what, exactly, your business will provide to its clientele in the way of products or services. You have probably already determined that. If not, you must do so now.

Identify Your Competition

Deciding on what your photography business will sell helps establish your niche in the marketplace. Knowing this makes it easy to identify your competition and how you will deal with it.

Identify Your Markets

Developing a sound marketing plan requires market analysis. You need to conduct some methodical but fairly simple research to determine who your potential customers are and how many are out there. Also consider the geographical area you are willing to serve with your business. How much travel are you willing to invest your time in?

If you intend to shoot school portraits, you need only determine how many students there are in your vicinity to arrive at a base figure. You may want to narrow your approach to include only high-school students, or maybe just graduating seniors. A few phone calls or online research will provide you with the numbers you need.

If you're a wedding photographer, every couple who gets married in your community represents a potential job. Call local venues and ask how many weddings they have serviced in the last year and how many they have booked in the upcoming year. If you contact a venue, multitask and set up an appointment to meet with the

events coordinator to show your wedding portfolio. Likewise if you are interested in commercial, industrial, real estate, architectural, legal, or medical photography. Internet research is the best place to start, along with getting information from local organizations such as the chamber of commerce.

If your chief area of expertise or interest is publication photography, most of your markets will probably be outside your community. Nevertheless, you shouldn't overlook local daily and weekly newspapers, Sunday or weekend supplements, city and regional magazines, local book publishers and advertising agencies, and any local company that produces house organs or employee publications. Add to this the stock agencies and national publishers of books, trade magazines, and popular periodicals, as well as publishers of calendars, posters, greeting cards, and postcards, and you will soon arrive at an impressive number of potential clients.

Determine Your Market Share

Determining your market share is a bit more difficult, but since it mainly requires guesswork, your figures aren't easily challenged. Be realistic and conservative in your estimates, and you'll probably outperform your best guess.

You might discover that you don't have the capacity to take full advantage of your market share. For example, let's say there are about five hundred weddings a year in your city. If you work alone, and you hustle enough to manage one wedding a week, that would be a 10 percent share of the market. As your name and work get known, you may well find that you have more business than you can handle, at which time you will no doubt want to consider expansion or collaboration.

Your marketing plan boils down to a fair assessment of the marketplace, how you will compete, who your potential customers are, what your market share amounts to, and how you will deal with growing demands on your business. After seeing to the necessary research and market analysis, put all this into narrative form and include it in your business plan.

Appendices

You may or may not wish to include appendices. If you have sterling credentials, though, you should seriously consider putting them into your business plan.

This is the place to include your résumé, a list of where you have published or exhibited photographs, a list of business and personal references, a list of credit references, and copies of letters of recommendation or commendation.

07

Taxes and Recordkeeping

These days, tax collectors seem to come at us from every direction. Depending on where you live and do business, you might have to pay city, state, and federal income taxes; self-employment tax; personal-property and real-estate taxes; city, borough, county, or state sales tax; state and federal fuel taxes; room tax; and an assortment of other taxes disguised as user fees, license fees, application fees, registration fees, permit fees, and filing fees.

You will need to determine the kinds of taxes you must pay in your city, county, and state. If you don't already know, check with your local Small Business Development Center, the chamber of commerce, or the local office of your state revenue department.

All of us must pay federal taxes, which we'll discuss momentarily. Because circumstances vary, even among people who are in the same business, and because tax codes and their numerous supporting documents exist in a constant state of change, it's impossible to provide specific advice. Furthermore, in the space of a chapter, I can provide only an introduction to taxes and taxation. I'll try to pass on some helpful tips and give you a good enough grounding in the concepts so you will be able to continue on your own.

In dealing with your taxes and essential recordkeeping, you can be involved at any level you wish, ranging from doing it all yourself to hiring others to do most of it for you. In any case you need to understand what your responsibilities are. Even if you decide to turn everything over to someone else, you will still have to perform some tax chores.

Your options are several. You can do your own bookkeeping or hire a bookkeeper. You can prepare your own tax returns and associated forms and schedules or have a professional tax preparer, accountant, or attorney do it for you. The choices are yours, but I am going to make some recommendations.

First, keeping books is relatively easy, so I suggest you do it yourself, especially the first year or so you're in business. This not only will help you contain start-up costs but also will introduce you to the fundamentals of recordkeeping.

I continue to do my own bookkeeping after all these years because it helps me stay in touch with the financial aspects of my business and lets me know how I'm doing from month to month. The best advice I can give is that you hire an accountant to prepare your taxes, one that is familiar with running a home business. You can provide this person with all the necessary paperwork and records you have meticulously kept over the year. This will save you time and hopefully money, as he or she should be up to date on the ongoing, revolving yearly tax changes for small businesses.

You can also try your skills at filing your own taxes. I'm not about to tell you that doing your own taxes is easy. It's a tedious, often confusing, sometimes infuriating task. Nevertheless, you may want to try your hand at it as a way of learning about taxation and how it affects your business. Once you've had the experience, decide for yourself whether to continue on your own or hire help. Learning how to keep books and prepare your tax returns enables you to provide better, more complete information when you decide to turn it all over to someone else.

You might want to try one of the computer-software packages designed for preparing tax returns, but a few caveats are in order first. These programs vary greatly in quality, you'll have to buy new software every year, and you might not like the results. NBC's *Today* show once did a review of several such programs, all of which led the user to make expensive tax overpayments. The reviewer recommended buying and using one of the programs as a way of keeping tidy records but then hiring an aggressive accountant to review tax returns and the various computer-generated forms. My advice is to shop carefully and ask colleagues and business acquaintances for recommendations before buying this or any other kind of software.

The tendency of most Americans is to put off the tax chores as long as possible. Don't join the herd, especially if you decide to prepare your own returns. You probably won't have all the documents you need until the end of January, so spend that month gathering all your essential forms, schedules, and receipts. Plan to work on your returns in February. That way, if you find you need help or discover that you don't have all the necessary documents, you'll have time and won't need to panic, or worse, pay a penalty for filing late.

Using Your Home for Your Business

As a home-based photographer, you should be able to take a tax deduction for any rooms you use exclusively and regularly for conducting your business. This can include an office, studio, darkroom, storage room, waiting room, shop, gallery, or combinations thereof. A studio, for example, need not be used exclusively as a studio, but it must be used exclusively as part of your business. My studio is a multipurpose room that houses my studio lights, seamless backgrounds, setup table, and copy stand, but it also has a desk and worktable where I do sorting, mounting, matting, and some framing. Much of my reference library is on the bookshelves that line two walls of my studio. Along another wall are filing cabinets. So this room functions as a studio, library, and storage area, while serving other business purposes as well.

If you plan to use only a portion of the space in a garage, basement, attic, or other large open area for business use, you might consider partitioning it to take advantage of allowable tax deductions. For example, you could partition off a room to use exclusively as an office or office-studio combination, thereby enabling you to take a business deduction for the square footage of that room, even though the remaining area may be used for personal or household purposes.

Another possibility would be to convert a spare room into a home office and partition off one corner of a basement or garage where plumbing is available to set up a darkroom. You could then take a deduction for the square footage of your office and darkroom.

Similarly, you can take a deduction for a room you use for storage. You cannot simply put up shelves or cabinets for business storage in a room you use for other personal or household purposes, then take a deduction for that space. You can, however, partition off that space to create a separate room, thus making that square footage eligible for the deduction.

What Is a Home?

House and *home* are not synonyms. A house is a building in which people live. A home is any dwelling that provides shelter for people or functions as a residence or multiple residence. You don't have to live in a house in order to qualify for deductions for the business use of your home. The Internal Revenue Service (IRS) uses the broader term *home* to mean "house, apartment, condominium, mobile home, or

boat." The IRS's definition also includes "structures on the property, such as an unattached garage, studio, barn, or greenhouse."

Use Test

You may be entitled to limited deductions for the business use of your home, but such use must meet certain criteria.

Exclusive Use

That portion of your home used for business purposes must be used exclusively for such purposes in order to qualify for a tax deduction. You can't use a room as a studio, sewing room, and guest quarters, then claim a business deduction for it or any portion of it.

Regular Use

You must regularly use this part of your home for business, but this stipulation has more to do with continuity than frequency. For example, if you mostly shoot color and send it out for processing, you can't justify taking a deduction for a darkroom you might use once or twice a year for clients who want black-and-white photographs, even if you use the room for no other purpose. If you regularly spend a day a week, or even only a day a month, working in your darkroom, that should constitute regular use on a continuing basis and should help qualify the room for the deduction.

Principal Place of Business

Here's a source of potential confusion. If you are a full-time home-based photographer, your home should qualify as your principal place of business, and the space you have set up for doing business should be eligible for a limited deduction. If you have a photography shop and studio downtown, however, and decide to set up an office at home for seeing to various business tasks, your home office probably would not be eligible under the current regulations, because it is not your principal place of business.

Interestingly, though, the IRS recognizes the fact that you can have more than one principal place of business, provided you're engaged in more than one business. For instance, if you teach photography full-time at a local community college and work weekends out of your home as a wedding photographer, you could have two

principal places of business: the college, where you are in the full-time teaching business, and your home, where you are in the part-time photography business. So you should be able to take the home-office deduction, so long as you meet the other criteria. Or you could be a lab technician, motorcycle mechanic, chef, plumber, cop, or computer programmer five days a week and run a part-time photography business from your home and still qualify for the deduction.

Separate Structures

The IRS also allows deductions for separate freestanding structures, such as a detached garage, barn, studio, shop, or storage building, providing it's used exclusively and regularly for business. If you have any such structures on your property, they might suit your purposes. Keep in mind, too, that as your business matures, it might outgrow its space. Separate structures could prove the ideal solution to that problem.

Trade or Business Use

According to the IRS, "You must use your home in connection with a trade or business to take a deduction for its business use." Your home-based photography business should easily meet this criterion.

Calculating Your Business Percentage

The allowable deduction for operating a business from your home is based on the percentage of total home space your business occupies. It's a simple matter of arithmetic accomplished in three easy steps:

1. Determine the square footage of your entire home.

2. Determine the square footage of your business space.

3. Divide the square footage of your business space by the total square footage of your home; the result is your business percentage.

Example: Let's assume you live in a two-bedroom apartment of 750 square feet and convert a 10 x 15-foot bedroom into a home office and studio. Multiply the room dimensions to arrive at the square footage (10 feet x 15 feet = 150 square feet). Now divide the square footage of the converted bedroom by the total square footage

(150 ÷ 750 = .20). Your allowable deduction is 20 percent. If you live in a house of 3,000 square feet and use 1,000 square feet for business, your allowable deduction is 33.33 percent. You see how it works.

The IRS allows you to use any reasonable method to determine your business percentage. The one I've described is the most accurate and is certainly easy enough.

What You Can Deduct

Expenses associated solely with your living quarters and other areas of your property that have nothing to do with your business are *unrelated expenses* and as such are not deductible. These include repair and maintenance of living quarters and most appliances, landscaping expenses, lawn care, and such.

If you need to repair or replace a dishwasher or range, no portion of the associated costs is deductible. On the other hand, some seemingly unrelated expenses might be deductible. For example, if a major part of your business is darkroom work, you might use as much water in your business as you do in your personal life, in which case repair or replacement of a water heater might be partly deductible.

Costs associated solely with the benefit of your business are known as *direct expenses* and are fully deductible. If you put new carpeting in your office, paint your studio, replace a faulty faucet in your darkroom, or hang a new light fixture in any part of your work area, you may deduct the expenses.

Most of the costs of running and maintaining your entire home are partly deductible as indirect expenses. They include mortgage interest, real-estate taxes, utilities, trash collection, some telephone charges, insurance premiums, and security systems.

Casualty losses, depending on their effects, can be unrelated, direct, or indirect expenses and are accordingly deductible or not. A grease fire that damages only your kitchen is a casualty loss but is unrelated to your business and not an allowable business deduction. If a storm blows the windows out of your office, the casualty loss is directly related to your business and is fully deductible, less any insurance compensation. If a tornado delivers your roof to an adjacent county, the loss affects both your business and your living quarters and is treated as an indirect expense, less any insurance or other reimbursement.

If you're a renter who meets all the criteria for the business use of your home, the business percentage of your rent is deductible. If you're a homeowner, however, no portion of your principal payments on your mortgage is deductible, but you should

be able to recover these business costs over several years by taking an annual deduction for depreciation of the building and any permanent improvements to it.

Limitations and Reporting Requirements

Your allowable deduction, including depreciation, for the business use of your home is limited. In simplest terms, deductions for the business use of your home are not allowed to exceed your net income. If they do, all or part of the deductions might be disallowed for that year, but those disallowed expenses may be carried over to a later year.

Form 8829, "Expenses for Business Use of Your Home," is where you report all this information and where you will determine whether or not your expenses for any given year are deductible that year.

Using a Vehicle in Your Business

It's hard to imagine running a home-based photography business without using a vehicle. Depending on the nature of your work, you may only occasionally need to drive or you might be on the road every day. You might buy a vehicle to use exclusively for business purposes, or you can enlist the family vehicle for both business and personal use.

The IRS uses the term *car* to mean any passenger vehicle that does not exceed six thousand pounds gross vehicle weight. That includes the kinds of vehicles most of us use for transportation: automobiles, vans, minivans, pickup trucks, and sport-utility vehicles.

Near Home and Away

Depending on the kind of photography you do, you might travel only locally or some distance to see to your business needs. Your business-home area includes the metropolitan, suburban, or rural area where you do business during the course of a normal workday or local job or assignment. If you travel to and from a job location within the same day, that's considered local use of your vehicle, and costs associated with such use are deductible as *vehicle* expenses.

If business takes you away from home overnight or for a longer period, you must consider your vehicle expenses to be part of your travel expenses, which are recorded and handled separately and reported in a different section of Schedule C, "Profit or Loss from Business."

According to the IRS, expenses for the local business use of your vehicle are deductible "if the expenses are ordinary and necessary. An ordinary expense is one that is common and accepted in your field of trade, business, or profession. A necessary expense is one that is helpful and appropriate for your business. An expense does not have to be indispensable to be considered necessary."

Vehicle Use Test and Expense Records

If you use a family vehicle for both business and personal purposes, business mileage must amount to more than 50 percent of the total mileage to qualify for the highest depreciation deductions. So you must keep good mileage records. How else could you know that of the 18,500 miles you drove last year, 12,580 were for business, allowing you to deduct 68 percent of your vehicle operating costs?

You should keep a mileage log, but it needn't be anything elaborate. Note the date and odometer mileage when you place a vehicle in service. Then for each trip, show date, business-related destination or purpose, and record your starting odometer mileage, ending mileage, and total mileage. You will also need to record the odometer reading on December 31 each year to indicate your ending mileage for the current year and beginning mileage for the coming year.

Your log can be a notebook or pad you keep in your car specifically for this purpose. You can also use this notebook to notate any maintenance you have done to your vehicle throughout the year, such as necessary oil changes.

Another option is to create a mileage-log form with your computer, make photocopies of it, run the pages through a three-hole punch, and keep them in a three-ring binder in your vehicle. Or you can buy a ready-made log, such as the At • A • Glance Auto Record, available at department stores and office supply outlets.

You may elect either to take a standard deduction for each business mile you drive or to deduct actual vehicle expenses and depreciation. In the latter case, you should also keep receipts, work orders, credit-card statements, canceled checks, and any other documents that substantiate your claims for expense deductions. There's no requirement to keep a separate diary or journal of vehicle expenses, but you may, if you prefer that to recording expenses in a general expense ledger. In either case, you need not duplicate any information already contained on your receipts and other documents.

DATE	DESTINATION/PURPOSE	STARTING MILEAGE	ENDING MILEAGE	TOTAL MILEAGE

TOTAL MILEAGE THIS PAGE_____

Mileage vs. Expenses

Whether to take the standard mileage deduction or deduct actual operating expenses is up to you. If your vehicle is cheap to operate, you might be smart to take the mileage deduction. You'll probably be better off deducting operating expenses and depreciation, however, if you drive an expensive gas guzzler.

In addition to keeping a mileage log, I recommend you record all your operating costs for the first year. At tax-filing time, do all the necessary calculations for both methods and pick the one that will give you the greater deduction.

Once you figure the total miles and business miles driven for the year, divide the business miles by the total miles to arrive at your business percentage. For example, if you drive 10,935 business miles and 3,645 personal miles, total mileage for the year is 14,580. If you divide 10,935 by 14,580, you'll find that your business miles constitute 75 percent of the total. That means you can deduct 75 percent of your operating expenses and depreciation, or multiply the standard per-mile deduction by 10,935 and deduct that amount.

Leasing a Vehicle

Another option is to lease a vehicle instead of buying one. With a leased vehicle, you are normally allowed to deduct maintenance and repair bills, operating expenses, and lease payments. You may not use the standard mileage deduction; nor may you deduct for depreciation. You must, however, log business and personal mileage.

Based on the kind of lease agreement you sign, the IRS might require you to treat the leased vehicle as you would a purchased vehicle. If your lease contains an option-to-buy clause, the IRS may consider this a purchase agreement. So be careful with any lease and its wording. You may wish to seek assistance from the IRS or your attorney before signing a vehicle lease.

If the vehicle you lease has what the IRS considers an "excess fair-market value," you will also have to report an "inclusion amount" when you file your tax return. For information about all this, see IRS Publication 463, *Travel, Entertainment, Gift, and Car Expenses*, or one of the commercially available tax guides published each year.

Renting a Vehicle

Should your business require you to travel away from your business-home area by public conveyance, such as by plane or train, you might need to rent a vehicle once

you reach your business destination. Your rental payments and operating costs are deductible as travel transportation expenses, as are your plane or train tickets.

Other Deductible Expenses

Unless you take the standard mileage deduction, most expenses you incur while operating your vehicle for business purposes are deductible. In addition to fuel, repairs, and maintenance, they include but are not limited to bridge and highway tolls, ferry fees, parking fees, parking-valet gratuities, and towing charges, should your vehicle become disabled.

Fines for moving and parking violations are not deductible; nor are towing charges stemming from illegal parking.

Using a Computer in Your Business

If you buy a computer that you and other family members use for personal reasons, schoolwork, computer games, and other nonbusiness purposes and you also plan to use it for business, the IRS considers this listed property, and you will need to keep track of and distinguish between personal and business use. If your business use is less than 50 percent of the total use, your deductions will be limited.

Logging computer use is more difficult than logging vehicle use, especially if several people use the computer. For that reason and others, I recommend you purchase a computer, put it in your office or studio, and use it exclusively for business. In this case, it is not considered listed property, and you may treat it as any other depreciable business property.

All peripheral computer equipment and hardware and most software are also depreciable property. External hard drives, compact discs (CDs), computer paper, ink cartridges, labels, and other essential computer materials are deductible as office supplies. (See Chapter 8, "Using a Computer in Your Business.")

Business Expenses

Most of the costs of running your business are fully deductible in a straightforward way. As the sole proprietor of a home-based business, you will have to sort out the various deductions and report them on their respective forms: some on Form 8829, "Expenses for Business Use of Your Home"; some on Schedule C, "Profit or Loss from Business"; and some on Form 4562, "Depreciation and Amortization."

We've already discussed deductions for the business use of your home and will more fully discuss depreciation later. For now, let's take a closer look at the kinds of expenses you will report on Schedule C. They include but are not necessarily limited to expenses incurred for advertising, business operation of a vehicle, interest paid, legal and professional services, materials and supplies, rent, leases, repairs and maintenance, taxes, licenses, permits, travel, some meals, entertainment, dues, some publications, printing and photocopying, postal costs, freight, express and parcel services, lab services, trash collection, and others you'll no doubt discover.

Keeping Records

Keeping receipts is not the chore so many people think it is. Mainly it's a matter of developing the habit of collecting receipts for all your business purchases.

The most important aspect of collecting receipts is to organize them as soon as they come in. And the best way to organize receipts is to set up a system that works for you. As a business owner, you will receive receipts for all kinds of expenses, including gas, photo and office supplies, and lodging and food when traveling. One way to organize these receipts is to create an individual file folder for each type of business-related expense: business phone, cell phone, credit cards, car maintenance and gas, office supplies, photo supplies, professional memberships, books and related publications, advertising/marketing, and travel. You can also create monthly folders in which you would store all your business-related receipts you receive within a month. Either way allows you to keep your business-related receipts organized in a way that will be helpful when it comes time to gather specific information for your taxes.

Once you set up a system that works for you, you'll have to keep up with filing your receipts. If, for some reason, you forget to ask for a receipt or do not receive one, as soon as you remember, write down all the necessary information: date, item(s) purchased, location, how you paid, and any information to support your purchase. This may be acceptable for these circumstances, but original receipts are always the best way to support your records.

Depreciation of Business Property

The purchase of certain equipment, tools, furnishings, and other property you use in your business is considered a capital expenditure, not normally eligible for deduction as an expense for a given tax year. Rather, it must be treated as depreciable

property, with the cost or other basis deducted gradually over a number of years. Normally this includes any property that has a useful life of more than one year.

In addition to vehicles and computers, which we've already discussed, other depreciable property you will probably use in your home-based photography business includes the following:

- Furniture and fixtures for your office, studio, and darkroom.
- Office equipment, such as a calculator, copier, fax machine, and telephone.
- Photography equipment, including cameras, lenses, flash units, and tripods.
- Studio equipment, such as floodlights, strobes, light stands, background stands, and duplicating equipment.
- Darkroom equipment, including an enlarger, enlarger lenses, safelights, and print dryer.
- Buildings not used for residential purposes, including the business portion of your home.

Property Classes and Recovery Periods

Various depreciable property is classified according to the number of years you must normally take to depreciate it or write it off. Because of conventions you're required to use in calculating depreciation, recovery periods run a year longer than their respective classifications. For example, so-called five-year property will remain on your books for six years, seven-year property for eight.

Any machinery you use—including office and photography equipment, computer equipment, and vehicles—is five-year property. Desks, chairs, filing cabinets, bookcases, tables, and other furniture and fixtures you use in your business are seven-year property.

The recovery period for nonresidential real property is thirty-nine years; the value of land may not be depreciated. The annual deductible rate for thirty-nine-year real property is 2.5641 percent, except for prorated first and last years.

Section-179 Deductions

Here's an exception to what we've been discussing. Certain tangible personal property used in business is eligible to be treated as an expense and may be fully or partly deductible for the tax year. You may deduct up to $102,000 of the cost of such property as office equipment, furniture, computers, peripherals, and photography gear.

Your business vehicle is eligible, provided it was not previously used as a personal vehicle and then converted to business use. The Section-179 deduction for qualifying vehicles is also limited.

Buildings are not eligible for Section-179 deductions.

You can use this information to your advantage by paying close attention to your earnings and expenses. If you have a better year than you anticipated, you might need all the immediate deductions you can legally take to reduce your taxable income. That's a good time to look for possible Section-179 deductions. If your income turns out lower than you expect, and you have plenty of deductions, you probably won't want to take the Section-179 deductions, even if you have purchased eligible property. Normal depreciation procedures will extend your deductions into future years, when, presumably, your income will be higher.

Reporting Depreciation

Enter all pertinent depreciation information on Form 4562, "Depreciation and Amortization." Once you have calculated your allowable depreciation, you'll enter the total on Schedule C.

Surmounting all the obstacles and wading through the mire of instructions for figuring depreciation can make for a difficult trip. This single aspect of taxation might be troublesome enough to make you seek the services of a tax professional.

If you want to try it on your own, you should consult IRS Publication 334, *Tax Guide for Small Business.*

Estimating Your Taxes

Uncle Sam doesn't like to have money owed to him at the end of the year, so we're required to keep our taxes paid up. In a simpler, saner system, it would be easy to do the bookkeeping at the end of the month, deduct a reasonable percentage from profits, and mail the old guy a check. But Uncle Sam also dislikes simple and sane systems. So we have yet another form to fill out and another exercise in exasperation.

If you're working part-time at this business and full-time elsewhere, you can increase the amount your employer withholds from your paycheck to keep from owing taxes at year's end. You could have a working spouse do the same, if you file jointly. Otherwise, you will have to estimate your income and taxes, file Form 1040-ES, and pay your estimated taxes quarterly.

Recordkeeping

As a self-employed taxpayer, you may use either the accrual or the cash accounting basis. With the accrual basis, you report income as it is earned, not as it's received. You also report expenses on the dates you incur them, not necessarily on the day you pay them. On a cash basis, you report income when you are paid and costs as you pay them.

Advantages of Cash Basis

Cash accounting is certainly the simpler method. It also offers certain advantages that can save you tax dollars. For example, at the end of a high-income year, you may elect to delay your billing until late December or early January in order to defer payment of money owed you into the coming tax year, thus reducing your taxable income for the current year.

No Set Rules for Records

You must keep accurate records of all your income and all your expenditures. There are no set IRS requirements for how you set up your books, so long as you maintain written records or computer records you can print out.

You can turn over your recordkeeping chores to a professional or do it yourself. You might want to visit an office-supply outlet to examine available commercial accounting and recordkeeping systems or devise something yourself. If you own a computer, you may wish to review some of the many software programs available for business and personal financial management and recordkeeping. Talk with friends and other home-based business owners for recommendations of useful software programs that they may be familiar with.

Depending on the nature of your business and how it is physically set up, you might find that keeping computerized records saves time. Among the dozens of software programs available, Quicken seems to be the most popular for personal and small-business financial management.

A Simple Bookkeeping System

I can't stress enough how important it is for you to keep organized with every aspect of your business, especially bookkeeping. Bookkeeping is the core of your business—it is how you will keep track of your income and outcome! As you begin your home-based photography business, you will need to create a system that works best for

you in tracking your expenses and income. There are computer programs that can help you set up a system for this, or you can manually organize a system for yourself. It may be the best learning experience to manually develop a system tailored to your own particular needs. As noted, each of us conducts our businesses in our own individual way, and this also applies to how we keep our records.

First, you need to organize a system for tracking your income and decide if you want to track this information on a monthly or per-client basis. A monthly tracking system is often helpful, especially after the first couple of years in business, as you may begin to see a pattern in how your yearly income flows. If there is a month that seems slower than others, you might be able to plan ahead for that slower period. A monthly tracking system also allows you to tally at the end of each month how much income you received.

As you receive payments, you will want to keep track of specific information, such as the date you received it, the method of payment, contact information for the payee, and specifics of the job that might help you coordinate the payment with expenses related to the job. You may want to give each job a job number, which will help you reference your income and expenses.

To keep track of business expenses, you can set up a chart where you list all business-related expenses by month or category. While you will tailor the categories to your particular business, you might want to include categories such as photo supplies, printing, office supplies, vehicle/gas, postage, membership dues, publications, insurance, phone, credit cards, travel and entertainment, and miscellaneous. You also might want to have a category for a freelance assistant. Whatever categories you decide to use, be sure to include each one on your chart and organize all your receipts related to these expenses by these same categories. And for each expense you record on your chart, be sure to indicate the date (month and year) of the expense and, if applicable, the job number or the client the expense is referenced to. While this may sound complicated, you may find that recording your expenses by category is simpler than recording them monthly. Keeping the expenses separated into categories will be helpful in gathering the information for tax purposes. Even if you list your expenses monthly, you will still need to separate this information within individual categories.

Whatever system you create for your bookkeeping, try and stay with the system for at least six months to see if it works for you. After that time, you may find that you need to make adjustments, such as adding additional categories to your expense chart or altering your income information.

DATE	CLIENT (Name / Contact info)	Payment Received / Method	Job # / Description

DATE	AMOUNT	JOB # / DESCRIPTION (if applicable)

Useful Publications from the IRS

Number	Title	Number	Title
17	Your Federal Income Tax	542	Tax Information on Corporations
334	Tax Guide for Small Business	544	Sales and Other Dispositions of Assets
463	Travel, Entertainment, Gift, and Car Expenses	550	Investment Income and Expenses
505	Tax Withholding and Estimated Tax	551	Basis of Assets
521	Moving Expenses	553	Highlights of [the Year's] Tax Changes
523	Selling Your Home	560	Retirement Plans for Small Business
525	Taxable and Nontaxable Income	561	Determining the Value of Donated Property
526	Charitable Contributions	583	Starting a Business and Keeping Records
533	Self-Employment Tax	587	Business Use of Your Home
535	Business Expenses	590	Individual Retirement Arrangements (IRAs)
536	Net Operating Losses	946	How to Depreciate Property
538	Accounting Periods and Methods		
541	Tax Information on Partnerships		

Capitalizing Start-Up Costs

To allow for a deduction of the preliminary costs of starting a business, the IRS requires those costs to be capitalized over time. Some of these costs might not be deductible until the business terminates. All of this can lead to some complicated and time-consuming recordkeeping.

For big companies making major investments in equipment and materials, the recordkeeping and procedures are necessary for taking the concomitantly large deductions. For the home-based entrepreneur, however, the small deductions are hardly worth the hassles.

You can simply elect not to take deductions for start-up costs. You won't have to do all that bookkeeping, and you won't run afoul of IRS regulations. But make sure you keep your start-up costs low. Anything you buy before you're in business is the kind of expenditure that would have to be capitalized to be eligible for deduction. Once you've made a sale, however, you are officially in business and may then begin deducting expenses in the same tax year they occur.

Of course, you will want to use tools and materials you already have on hand; you just shouldn't take deductions for them if you want to avoid the capitalization hassles.

My recommendation is to keep your start-up costs minimal and to make a sale as soon as possible. Don't buy new office furniture and equipment or lay in large quantities of materials and supplies before you've sold anything. Operate on a shoe-string until you make a sale; then begin purchasing the necessities for your business, keeping all the receipts and maintaining careful records of all expenditures.

IRS Forms You'll Probably Need

Number	Title
Form 1040	U.S. Individual Income Tax Return
Form 1040-ES	Estimated Tax for Individuals
Form 4562	Depreciation and Amortization
Form 8829	Expenses for Business Use of Your Home
Schedule A	Itemized Deductions
Schedule B	Interest and Dividend Income
Schedule C	Profit or Loss from Business
Schedule D	Capital Gains and Losses
Schedule SE	Self-Employment Tax

Sales Tax

Depending on the nature of your business and your state's requirements, you might have to apply for a license to collect sales tax on the items you sell.

If your state has a sales tax, you might have to collect taxes on items you sell directly to customers at arts-and-crafts shows, craft fairs, and similar events. On the other hand, you probably won't have to collect taxes on items you sell through shops, galleries, stores, or any other retail outlets where the proprietors of those businesses collect taxes from their customers. Similarly, you should be exempt from paying sales taxes on raw materials and finished products that you purchase for resale. The idea here is to prevent what would amount to multiple taxation on the product as it progresses through the stages of manufacture.

You'll need to determine your state's requirements. So check at your local chamber of commerce or Small Business Development Center. You can also get information from your state revenue department.

08 Using a Computer in Your Business

Along with your camera equipment, the most important and expensive investment you will make for your home-based photography business is your computer system. This system is absolutely essential for you to run your business efficiently. It is your lifeline to the outside world, keeping you connected, organized, and moving forward in an ever-changing business environment.

This chapter will be a general overview of what you should consider in either purchasing a new system or upgrading what you already own. Since this is an area of considerable investment, take your time before you finalize any decisions related to your computer needs. It is worth the investment, and all computer purchases related to your business can be considered business expenses—so keep all receipts.

Getting Started with a Computer

You probably already use a computer at home. If not, it's time to start. It is difficult to stay connected to others for personal or professional purposes without a computer. It is a standard purchase for most households these days. Since you are thinking about starting a home-based photography business, you may want to consider purchasing a computer solely for your business, especially if you presently share a computer with family members. A computer for your photography business will hold all your important information, including all your digital files, contact information, and possibly financial files. Therefore, you would want to limit this computer's use specifically for your business.

As with most expensive purchases, research is essential. Before you finalize any decision, go online to research what you may need to run your business. There are many different computer companies and software programs geared toward photography. Try to narrow your choices so your initial purchase or

upgrade of your present computer will not be too overwhelming financially. After you have done your research, visit a local computer store to actually see what is available and talk with a dealer. The more educated you become, the wiser you will be in making your purchase.

What a Computer Can Do for Your Business

It's a good idea to use a computer in your photography business because it will help keep you connected and organized and, along with supporting software and a printer, will operate as your digital darkroom. Because a computer for a home-based photography business has to handle so much, it is essential that you use one that has enough power and memory to support your needs. Your computer can be a multipurpose assistant to the overall function of your business.

Because you will work out of your home, it is essential to use the Internet to stay connected to others through e-mails and other social networking avenues (see Chapter 10, "Marketing Your Photography Business," for more information). Communicating via the Internet helps save time, as you no longer have to make phone calls. Your computer can also serve as your digital darkroom. Viewing, storing, adjusting, printing, and sharing your images are all done with your computer and printer. If you are fortunate to have a local custom-printing lab you like to work with, you will still need a computer to prepare your files before handing them over to that outside source. All your recordkeeping and possibly bill paying can also be done on your computer.

Master the Jargon

Do not be intimidated by all the computer terms and jargon. There are many supportive computer resources online that can help you understand these terms, especially if you are a computer novice. Another good resource is the variety of computer magazines available online, at the library, or at newsstands and bookstores. Take time to educate yourself and you will begin to understand the difference between RAM and a router. Read as much as you can in the areas that pertain to your interest and needs.

Take Computer Courses

If you have just basic computer skills or are not familiar with some of the software programs specifically used for photography, such as Adobe Photoshop or possibly

an office-related program, you should consider taking a course in one of these areas. Find out what is offered at local community colleges, adult education programs, your local library, or computer stores. Some information may also be available online through webinars. Webinars are seminars offered online. Podcasts are also available online and offer opportunities to learn more about the business of photography or computer software programs. You will discover that some software programs frequently change or are upgraded; therefore it is helpful to stay current with the technology you use by educating yourself.

Find a Friend or Computer Wiz

If you are truly lacking in computer skills, find a friend who has already been working with various computer programs. Everyone has a different learning curve or capacity. Learning new computer programs or dealing with computer glitches is time-consuming and frustrating. Make connections with others who are more experienced in this area. It may be worth your time to pay someone a consulting fee to answer your questions or help you set up your computer system. Time is money, and computer issues can take up a lot of your valuable time.

Hardware Overview: What to Consider

The very basic components for a computer system consist of the main computer, keyboard, monitor, and mouse. There are a variety of computer brands to choose from along with choices on memory and speed capabilities. You will also need to investigate what accessories, if any, come with the computer. These may include some basic software programs to help you get started along with limited warranties. Consider what you will be using your computer for, and start from here.

Desktop vs. Laptop

To begin, you will need to decide between a desktop and laptop computer. A desktop computer is just that, it is stationary and remains in your office or studio. There are several advantages to desktop computers. For one, they are generally less expensive than laptops. Desktops also have the capability of accommodating a larger monitor, which is beneficial when working with photographic images. Desktops also have faster processors than laptops.

Laptop computers (also referred to as notebooks) are portable and have several other advantages. If the majority of your work will be on-location or travel

photography, you may want to consider the portability and convenience of a laptop computer. Laptops take up less space and use less power to operate than desktops. And as long as there is a wireless connection, you can use your laptop just about anywhere—in your front yard, in a coffee shop, or at a friend's house. A major draw-back with laptop computers, however, is that they are easier to steal or damage than desktops. They are also expensive to repair or upgrade.

Try to project what your needs will be over the next few years and hopefully, along with supported research, you will have a better idea which would be the best choice for your business.

Monitors

A monitor is an external screen you use to view information generated from your computer. Laptop computers have built-in monitors. A monitor is often included in the package when you purchase a new desktop computer. The most recent models of desktop computers have sleek, flat, space-saving (LCD) monitors that replace the bulky, boxy (CRT) models of the past. LCD (liquid crystal display) monitors use less power, which is beneficial for the environment, and have a longer lifespan than CRT monitors, which will be helpful to your pocketbook. Fewer CRT (cathode-ray tubes) monitors are being manufactured as the price on LCDs is lowering and they becoming more mainstream.

Monitors are available in a variety of sizes, ranging from eighteen to fifty-four inches. The display size is the diagonal measurement from one corner of the screen to the other. Larger screens—but not necessarily the fifty-four-inch size—are recommended for any type of photography work. You also want to pay attention to the monitor's maximum resolution. Maximum resolution refers to how many tiny squares, called pixels, make up the display. The resolution is based on the number of pixels from left to right and top to bottom of the screen. The higher the resolution, the more pixels, the sharper the image, and the higher the cost. A monitor with a resolution of 1,600 x 1,200 will be more expensive and have a sharper image than one with a resolution of 1,440 x 900.

You may also want to consider a height-adjustable stand for you monitor.

Printers

Ink-jet and laser printers are the most popular types today, and many makes and models fit the needs and budgets of home-based businesses. In general, laser

printers are more expensive than ink-jet printers, but many of the midrange machines are comparably priced. There are a variety of companies that sell printers specifically geared toward professional photographers and office use.

Choosing the right type of printer for your business depends mainly on your needs and expectations. Will you be printing archival-quality photographs, or will you have a professional lab do your photographic printing? If you are interested in printing at your home studio, what size photographs will you be printing? Are you interested in printing high-quality black-and-white photographs?

If you need color capability, you will probably want to invest in the best ink-jet or color laser printer you can afford. If you need to produce large quantities of computer-generated digital images of the highest possible resolution, however, you'll no doubt want to look into high-end laser printers with color capabilities.

An ink-jet printer can be a good option for your home-based photography business. They range in price and quality. Even though they use up a lot of ink, they can produce overall good quality prints and have archival capabilities. Again, you need to consider what your needs will be.

As you begin to calculate your printing expenses, remember to include the cost of the ink cartridges and photo paper your printer will use. Once again, do your research and, if possible, ask other photographers what printers they use. When you have narrowed your search, try and have a demonstration of the printer before you make your final purchase. You could contact a local dealer for a demonstration or attend a photography trade show that may offer demonstrations on a variety of photography products. The best way to find information about photography trade shows in your area is to google "Photography Trade Shows or Expos."

Memory

Random-access memory (RAM) is among the most important considerations in the purchase of any computer. This is the computer's main working memory and a major determinant of a computer's capacity for accessing program instructions and data. Generally, the more RAM a computer has, the faster and more efficiently it will operate.

Internal and External Hard Drives

Just as minimal requirements for power and speed keep increasing, so too does the need for hard-drive capacity. The hard drive is where you store your applications.

An internal hard drive is the storage device inside your computer. It stores all your programs and data files.

Because you will be working with a large quantity of important material, you should also store digital files on an external hard drive. This additional external transfer of files is referred to as *backup*. Make sure your internal and external hard drives have the speed and capacity necessary to store a significant amount of information. Some photographers keep their external hard drives stored in waterproof and fireproof safes for additional protection. Once you have an external hard drive, don't forget to use it. Your work is based on your images; you do not want to lose valuable files because you carelessly forgot to back them up. Always back up your files on a regular basis.

You can also store and back up files by burning them onto CDs (compact discs) or DVDs (digital video discs). CDs make sense for photographers who shoot JPEGs (a compressed file format). DVDs are a good option for backing up files because they can hold large amounts of data. You'll need a CD-RW drive (also known as a CD burner) to copy, write, and rewrite CDs. Such drives are currently standard equipment on desktop computer systems. Buy good quality CDs and DVDs specifically made for photography purposes, then label and store the discs in a dry, safe location. Use only a CD-safe marker when writing on your discs.

Software Overview

Software is what makes a computer work. Without software, a computer is useless, incapable of functioning. Software can be divided into three general categories: systems, applications, and utilities.

Your computer will come with basic operating-system software already installed. This is the software that controls the computer, manages memory, formats disks and diskettes, and enables the user to create, copy, move, and erase files, as well as run applications software.

Applications software sets up your system to do specific jobs, such as word processing, spreadsheets, accounting, desktop publishing, CAD, drawing, painting, and digital imaging. With the right applications software, your computer can print all kinds of graphics and forms, track and manipulate digital files, address envelopes and labels, create calendars and to-do lists, remind you about meetings and appointments, and help with bookkeeping, taxes, and bill paying online. You will want to invest in software programs specifically designed for your photographic needs.

For example, you might consider purchasing Adobe Photoshop CS5 and Photoshop Lightroom 3, two software programs that together provide solutions for importing, processing, managing, and showcasing your images. As with most programs, as soon as it is released a new and improved version will be in the works. Keep in mind what works for you and your budget. Make sure that you get software programs that are compatible with your digital camera.

Before deciding on any computer system, you must determine the kinds of applications software you want to run, then customize your system around the requirements of the software. Your computer may come with some software, and by shopping around you might find package deals with software bundles that include some of the name-brand software you want.

Major software manufacturers, such as Microsoft and Corel, offer their top software titles grouped in "suites" that sell for not much more than any single program in the suite used to cost. With Microsoft Office, for example, you get that company's topflight applications, including Word (word processing), Excel (spreadsheet), Access (database), Outlook (e-mail, scheduling, and task management), and Publisher (desktop and Web site publishing). Corel's WordPerfect Office offers the same versatility along with what some of us consider the best word-processing program available.

Regardless of your individual photography and business needs, certain categories of applications software are essential to most, if not all, businesses. At the top of the list is word processing. Spreadsheets and heavy-duty accounting programs are essential elements in the corporate world but are often too much for the home-based business, where simpler financial programs are usually better and easier to use. Other programs can help you manage your time and put it to better use.

Buying a Computer System

For most of us, houses and vehicles represent our largest purchases. But computers are up there too. If we were to evaluate such purchases, however, in terms of complexity, confusion, and frustration instead of cost, computers would certainly rank in the top three. For many of us they would shake out as number one.

Regardless of where you buy a computer system—from a direct-sales (mail/phone/online-order) company or local store—you will need to study and evaluate your many options. Even after you've done all your homework and think you know what you want, you'll probably experience more than a little difficulty dealing with

all the configurations, combinations, and permutations the various companies offer.

In the search for my second desktop system some years ago, my reading, research, and phone calls eventually narrowed the field to three of the top-rated computer companies. Trying to make intelligent decisions in the face of dozens of configuration options was exasperating. Juggling all the figures and features became remarkably easier, though, when I designed a simple form for comparing the various makes and models.

To use my Computer Systems Comparison form, make a copy of it and fill in your minimum system requirements in the left column. Then make enough copies for all the system configurations you're researching.

On the blank line at the top of the form, write in the brand name and configuration or model number of the system under consideration. Show the configured system's price at the bottom of the form. In the center column, fill in the system's standard hardware, software, peripherals, and features. In the right column, list any upgrades and options of interest and their cost. Then it's a simple matter of running the figures, adding shipping and other costs, and arriving at a total system price.

You'll be amazed at how this simple form helps you sort out the profusion of confusion that accompanies the purchase of a new computer system.

Setting Up Your Computer

After spending a little time with computer magazines, contact the manufacturers of those computers that seem best suited to your needs. Get online and visit the companies' Web sites to review product lines and specifications, or you can call the companies on their toll-free lines to request literature about their products.

Sources for everything mentioned in this chapter appear at the end of this book in the Source Directory, under "Computer Companies" and "Direct Sales Outlets: Computer Products." Browse through the directory, visit the Web sites, and phone, write, or e-mail for catalogs.

When you purchase your computer, it may be wise to buy an additional or extended warranty. If anything goes wrong, this will give you a place to call and get immediate assistance. Just be sure to find out exactly what's included with the warranty and for how long. The company may offer assistance in setting up your computer once you get it home, and if you ever have a problem, you may be able to fix it with proper instructions given to you over the phone.

	MINIMUM REQUIREMENTS	CONFIGURED SYSTEM	UPGRADES AND OPTIONS
Processor			
RAM			
CACHE			
Hard Drive			
CD-ROM			
CD-RW			
DVD-ROM			
Monitor			
Modem			
Graphics			
Sound			
Speakers			
Case			
Warranty			
Operating System			
Software			
Extras			
Extras			
Extras			

Configured System $ _____ Shipping $ _____

Upgrades & Options $ _____ Other Costs $ _____

Installation $ _____ Total for System $ _____

Once you've made your purchase, bring your computer home, read the manual, and, if you need to, call a friend or computer wiz to assist you in setting up your new system or upgrading what you already own.

Before you set up your computer, however, consider where you want to place it in your home office/studio. Make sure you place it in a comfortable and convenient location, since most of your time outside of taking pictures will probably be spent at the computer. Make sure there is no glare from outside light or another light sources that might interfere with the proper viewing of your screen. If this is a problem, you may want to purchase a hood for your monitor to help control reflective light. It may be helpful to set up your computer on a table with lockable wheels, just in case you need to move the computer around your work space.

Computers and software are constantly being improved and upgraded. Try not to become frustrated when a new, fancier version of your computer or software program comes out soon after your purchase. This is marketing, and as with cameras, newer, faster, sharper versions are always ready to replace this year's model. Do your research, put together a computer system that you feel will fulfill your needs for the next few years, and begin to expand your home-based photography business.

09 Managing Your Photography Business

Just as there are different photographic styles and innumerable ways to compose, light, and shoot any subject, so too do management styles vary greatly. Moreover, what works for one manager may not work for the next. Successful management styles are based on sound business principles, experience, good sense, and integrity.

Plenty of books and articles are available on various facets of business operation, particularly those of small-business management. You must learn from experience, which is another reason for starting your home-based photography business on a part-time basis. Moreover, you should possess certain attributes that are even more important than education and experience.

The most important characteristics you need to have if you want to start and run a home-based business are good organizational skills, discipline, and focus. Along with professional photography skills, common sense, good communication skills, and integrity will also be key factors to your success. If you are easily distracted or unorganized, starting a home-based business may be a very challenging and frustrating experience. You will be your own boss and manager, and possibly along the road you will become someone else's boss, too. Distractions come more easily with a home-based business. You need to be extremely focused and disciplined each and every day in order to successfully manage your business.

In this chapter, I will explain how to set goals and effectively schedule and manage your time so that in addition to running your business you also have time to be a creative and productive photographer. Think of managing your business as another creative outlet. Utilize your skills and passion to create a successful business on your own terms. You will find that flexibility is a

key element to accomplishing this goal. There will be days when you need to allow yourself time to "depart the text" and go out and photograph just for yourself. This is extremely important, especially in such a creative field as photography. You have to work time in for your personal creative process. After all, your passion for photography was more than likely one of the reasons why you decided to start your business in the first place. And you should be able to take a day here and there to create for yourself—as long as you are on task with your business-related responsibilities. Don't lose touch with your creative drive. This will add to your success, and people will respond to your enthusiasm.

Setting Goals

We're often told that as business managers we must set goals, both short-term and long-term. Common sense tells us that no one could expect to run a successful operation without knowing what to do tomorrow, or next week, or three months from now. Continued success depends on knowing what to do next year and the year after. That, simply, is what goal setting is all about. If you are planning to open your own home-based photography business, you have set a major goal. If you're working on a business plan, you're engaged in both short-term and long-term goal setting.

Short-term attainable goals keep us moving forward and allow us to see that we are getting work accomplished. It is also important to set challenging and more difficult goals, ones that will push us out of our comfort zone and expand our capabilities. Attaining these goals creates milestones in our growth both professionally and personally. Challenge yourself and see what you can accomplish.

Job Planning, Forecasting, and Scheduling

In Chapter 4 you learned that the operation of your business amounts, in large part, to the management of money and the management of time. If you properly manage money and time, your business will probably succeed. But your success is based on much more than just being a good manager of time and money. Organizational skills and how you present yourself professionally are also important factors.

Managing Time

Time management is a matter of knowing all you have to do and how much time you have to accomplish it, then assigning priorities to most tasks and creating a schedule that allows you to get everything done. You can't get by with managing

only your business time; you must manage all your time to make room for the many jobs, chores, and attendant details in your busy life.

Making Lists

If you're not a list maker, it's time to start. It will be the best thing you do for yourself as the manager of your own business. Making lists is a great way to start off your workweek and keep you on track with daily and weekly tasks. Do not make the lists so overwhelming that you feel unable to attain these short-term goals, however. And make sure you check off what you have accomplished, even if it is as simple as "go to the post office." These are the short-term goals that keep you moving forward through your week.

You can make a list for each day of the week or set up lists in categories, such as photography, marketing, phone calls, photo supplies needed, and so on. It is also helpful to date your lists and make new ones weekly or biweekly—whatever works for you to keep track of all you need to accomplish.

Scheduling Work

You should set up a time to start work each day and stick with your schedule. Whatever you do within this time frame should be related to running your photography business. If you need to schedule in time for a school meeting or doctor's appointment, make sure it works into your schedule and will not take too much time away from your work. Even if you are not photographing with or for a client, there are many tasks that you need to continually attend to on a weekly or monthly basis, such as checking and responding to e-mails, marketing your business, updating your Web site (we will discuss this in Chapter 10, "Marketing Your Photography Business"), calling clients, or just maintaining your files. There is always work to do and connections to be made.

Long-term scheduling and planning are also important for managing your business. Keeping a calendar to remind you of particular dates, appointments, or meetings is extremely helpful, as you are your own personal assistant. Your organizational skills are incredibly helpful for scheduling.

Setting Priorities

As you create your lists and schedules, you will find that certain items continually rise to the top. These items are usually the higher priorities. Mark them in some way,

possibly with a star or a highlighter. We all have priorities, and many times these priorities change. It may be helpful to always write your priorities at the top of your list so you will know the importance of getting these accomplished. It may take a few weeks or months to complete the task, but keep it at the top of your list.

Business Planners and Calendars

There are a variety of business planners and calendar options available at office supply stores. If you choose to use one for your business, you may find it difficult to find one that fits your individual needs. You can customize one with software on your computer if you have the capability.

Using a planner or calendar is especially helpful for keeping track of meetings and contacts. You may be planning a marketing campaign for a particular time frame and want to make sure you set aside the time needed to prepare it and target a date to send out the information.

A planner or calendar is helpful on your desk, hanging on the wall, in your computer, or on a handheld device such as a Blackberry or iPhone—all serve the same purpose. Make sure that whatever you choose to use is convenient for you to use, manage, and gain access to.

The following charts offer various options for you to use as daily, weekly, and monthly planners. You can customize your own planner as to what works best for your business.

Storage, Filing, and Retrieval Systems

With the widespread use of computers, much of our paperwork is now stored in "folders" on our computers. To some degree, our computers have become our filing system, holding documents and correspondence that are important to our business. Even with this assistance from our computers' filing systems, however, each and every business in America is confronted with the management of paperwork.

Creating a physical filing system is extremely important to the organization of your space and time. You have to be able to retrieve information when you need it without wasting valuable time. Unfortunately, many people tend to allow paperwork to clutter up their offices and floors. And you do not want the floor of your office piled with paperwork.

As a professional photographer, you also need to create storage and retrieval systems for your digital images and prints—and possibly your negatives and

MONDAY: _____ / _____

Appointments/Meetings:

1. _____
2. _____
3. _____
4. _____
5. _____

Must Do (Priority 1):

1. _____
2. _____
3. _____
4. _____
5. _____
6. _____
7. _____
8. _____
9. _____
10. _____

Should Do (Priority 2):

1. _____
2. _____
3. _____
4. _____
5. _____
6. _____
7. _____
8. _____
9. _____
10. _____

Try to Do (Priority 3):

1. _____
2. _____
3. _____
4. _____
5. _____
6. _____
7. _____
8. _____

Phone/E-mail/Letters:

1. _____
2. _____
3. _____
4. _____
5. _____
6. _____
7. _____
8. _____
9. _____
10. _____

Notes/Reminders:

Journal:

MONDAY: _____ / _____ **TUESDAY:** _____ / _____

Notes: _____ Notes: _____

_____ _____

_____ _____

_____ _____

_____ _____

Appointments/Meetings: Appointments/Meetings:

_____ _____

_____ _____

_____ _____

_____ _____

Phone/E-mail/Correspondence: Phone/E-mail/Correspondence:

_____ _____

_____ _____

_____ _____

_____ _____

_____ _____

Must Do Today (Priority 1): Must Do Today (Priority 1):

_____ _____

_____ _____

_____ _____

_____ _____

Should Do Today (Priority 2): Should Do Today (Priority 2):

_____ _____

_____ _____

_____ _____

SUNDAY: _____ / _____ **JOURNAL**

Notes: _____

Appointments/Meetings:

Phone/E-mail/Correspondence:

Next Week:

Must Do Today (Priority 1):

Should Do Today (Priority 2):

MONDAY: _____ / _____

Notes: _____

To Do Today:
1. _____
2. _____
3. _____
4. _____
5. _____
6. _____
7. _____
8. _____
9. _____
10. _____
11. _____
12. _____

TUESDAY: _____ / _____

Notes: _____

To Do Today:
1. _____
2. _____
3. _____
4. _____
5. _____
6. _____
7. _____
8. _____
9. _____
10. _____
11. _____
12. _____

WEDNESDAY: _____ / _____

Notes: _____

To Do Today:
1. _____
2. _____
3. _____
4. _____
5. _____
6. _____
7. _____
8. _____
9. _____
10. _____
11. _____
12. _____

THURSDAY: _____ / _____

Notes: _____

To Do Today:
1. _____
2. _____
3. _____
4. _____
5. _____
6. _____
7. _____
8. _____
9. _____
10. _____
11. _____
12. _____

FRIDAY: _____ / _____

Notes: _____

To Do Today:

1. _____
2. _____
3. _____
4. _____
5. _____
6. _____
7. _____
8. _____
9. _____
10. _____
11. _____
12. _____

SATURDAY: _____ / _____

Notes: _____

To Do Today:

1. _____
2. _____
3. _____
4. _____
5. _____
6. _____
7. _____
8. _____
9. _____
10. _____
11. _____
12. _____

SUNDAY: _____ / _____

Notes: _____

To Do Today:

1. _____
2. _____
3. _____
4. _____
5. _____
6. _____
7. _____
8. _____
9. _____
10. _____
11. _____
12. _____

JOURNAL

Next Week:

WEEK: _____ / _____

Appointments/Meetings:

Notes/Reminders:

Photography:

1. _____
2. _____
3. _____
4. _____
5. _____
6. _____
7. _____
8. _____
9. _____
10. _____
11. _____
12. _____
13. _____
14. _____
15. _____
16. _____
17. _____
18. _____
19. _____
20. _____

Phone/E-mail/Letters:

1. _____
2. _____
3. _____
4. _____
5. _____
6. _____
7. _____
8. _____
9. _____
10. _____
11. _____
12. _____
13. _____
14. _____
15. _____

Chores:

1. _____
2. _____
3. _____
4. _____
5. _____
6. _____
7. _____
8. _____
9. _____
10. _____
11. _____
12. _____
13. _____
14. _____
15. _____

Top Priority/Must Do:

1. _____
2. _____
3. _____
4. _____
5. _____
6. _____
7. _____
8. _____
9. _____
10. _____

JANUARY

Appointments/Meetings:

Top Priority/Must Do:

Photography:

Business/Household Chores:

FIRST QUARTER

January Projects:

February Projects:

March Projects:

Household Projects:

Deadlines:

Royalities Due:

transparencies, if you have them. The digital management of your files is extremely important for your business. You need to create a system that is both efficient and safe. If you have negatives or slides from years ago, you may want to scan them into digital files. Keeping track of your work is an ongoing task and one of the consistent priorities.

The Reference Library

Most of us have a collection of photography and reference books we like to keep on hand for reference or inspiration. Your particular collection may also include all kinds of odds and ends, including old textbooks that you simply can't part with. And it's always a good idea to keep current computer software manuals in case you have questions or problems.

No matter how large or small your collection of books, you want to create an organized and efficient reference library. The bookshelves you use can be as simple as plywood and cinderblocks or as elaborate as professionally manufactured wood shelves. Only you know what your space and budget will allow.

Magazines are a great reference tool, but they can clutter up office space. One way to avoid this is to keep up with them: Read them and then pass them on to someone else, donate them to a library or local school, or recycle them. If you want to keep any magazines, magazine files are a great way to store them. You can also purchase flat files for larger prints, posters, or other reference materials that you want to store in a safe place. Filing cabinets can hold additional reference materials and necessary paperwork. Most office- or photo-supply stores sell a variety of storage items for your materials.

Business Files

In addition to your reference materials, your business files are important and need to be properly stored so you have quick and easy access to this information when you need it. Keeping current with your files is another ongoing task. Set aside time on your to-do list for paperwork. Paperwork and mail can easily pile up if not attended to on a regular basis. And maintaining good business records and an organized filing system helps keep you on track with your income and expenses from year to year.

Your filing cabinet should be part of your overall organizational plan. If it is large enough, you may want to designate a section for recent business files, including tax- and banking-related paperwork. Consider color coding your file system to help with retrieving information. Once you have discarded what you don't need, file the

rest as soon as you can so this task doesn't become overwhelming. Try to update your business files yearly. This will be particularly helpful with tax information. For the paperwork you do not need, I would recommend investing in a paper shredder so you can discard documents or information without worrying if someone will be able to access your personal information. Identity theft is a serious issue, especially when you're operating a home-based business and not only personal but also professional information is coming into and out of your home office/studio.

Do not throw away any important files. You never know what you may need to reference from one year to the next. When you are reordering an item, for example, you may want to reference what you were charged the last time you made the same purchase. I annually reorder card stock for my photo cards, and I keep track from year to year what I have been charged.

Dead Files

Filing cabinets are expensive. Corrugated filing boxes are cheap. Use filing cabinets for all your important active files. Use the corrugated filing boxes for dead files—those that aren't active but must be retained for one reason or another. Tax files for previous years, for example, can go into a dead file instead of taking up valuable space in a cabinet. You'll no doubt find other files you must keep but don't use very often that would be better routed to a dead file.

Quill Corporation and other office suppliers sell boxes for this purpose. As you fill each box, label it clearly with a felt marker, and store it in any dry storage area. Although you can box up any kind of paperwork for dead storage, don't store photographic material this way. Old negatives, contact sheets, transparencies, and prints require special handling and filing.

Photographic Filing Systems

The accumulation of digital images can be overwhelming. For each job you can have hundreds or thousands of images that need to be downloaded (the transfer of image files from camera to computer), edited, processed, and stored onto your computer. And then you have to be able to easily and efficiently retrieve those files when you need them. It takes time to set up a system that works with your particular photographic workflow, but it is a necessary propriety to create an efficient system for all your photographic files, whether they be recent digital files, negatives, contact sheets, or transparencies.

Digital File Management

Since most of your images will be captured digitally, having a storage system in place will help you manage your workflow. First, I would suggest that you invest in an external hard drive that you use specifically for storing your digital files, including any digitally scanned negatives or transparencies. This is an efficient system and gives you peace of mind, knowing that your images are safely stored outside your computer's hard drive where they will not be lost if for some reason your computer fails or crashes.

The following digital management workflow is just a suggestion. You may create your own or adjust what I have suggested to fit your needs. In any case, you should create a workable digital filing system for your business. Photographic software specific for digital file management is available, such as Adobe Lightroom. Once again, research available programs.

After you've transferred your images onto your computer, store them in designated folders. Create a yearly folder as the first tier of your filing system, and then create secondary folders for each month. Within each month's folder, create a new folder for each job or day of shooting. You can also create additional "edited" folders so that it's clear to you which images you have adjusted, named, or rated.

Give folders clear and concise names to help you quickly and easily retrieve images when you need them. Include the date and name of the person or event in each folder's name and indicate if it is an original or a copy of the original file. Keep folder names as concise as possible, because some CD and DVD burning programs allow only a limited number of characters .

You have transferred your digital images onto your computer and have put them into clearly labeled folders on your hard drive. Before you erase the memory card in your camera, however, you need to back up your folders onto an external source. Backing up your files simply means making another copy of your files and storing them on an external source, separate from your computer's hard drive. This could be an external hard drive specifically designated for your photography files, a CD, or a DVD. Blank CDs and DVDs are inexpensive and should be labeled with a marker made specifically for this purpose. They also should be stored in a hard case in a cool, dry location away from direct sunlight.

Store additional backup files in another location—away from your office—possibly in a water- and fireproof safe, also designated specifically for your photographic files. It may seem unnecessary, but these files are the lifeline to your

business, and if you lose these files, you may lose potential income. The upfront investment in time and cost is worth every penny. As with other aspects of managing your business, management of your photographic files should be one of your most important priorities.

Archival Storage for Negatives and Transparencies

If you need to store negatives, contact sheets, or transparencies, I would suggest doing so in a loose-leaf binder that holds negatives and transparencies in archival-safe transparent plastic pages. They store neatly on a shelf or in metal filing cabinet drawers. This system is simple and efficient.

Plastic storage pages are available from various companies. Many are similar or nearly identical, so look for the best prices and features. Print File is one brand I have used and can recommend. The company offers pages for 35mm and 120 film, as well as 35mm slides. These clear polypropylene pages protect the contents from smudges, dust, and fingerprints. They allow slides to be viewed and negatives to be contact printed without removal.

As with your digital filing system, you need to create a system to indicate what images you are filing. These negative or transparency files may be from past years. If you have not already started a filing system for these images, I would suggest you start by filing them by the year the images were taken. Then indicate the person, event, or identifiable content to assist in filing and retrieving the images.

Filing and Retrieval System

For organizing negatives, contact sheets, and transparencies, create a filing system that coordinates with an ongoing chart. Your system can be as simple as creating a file number, date, subject, or job information. If there is a contact sheet, mark it and indicate this on the filing chart, and if you have multiple binders, indicate in which binder the work is stored. It is important to coordinate filing numbers and information on both the original materials and the chart. Cross-referencing this information is similar to having backup files for your digital images. Keeping your filing systems as streamlined as possible will make the management of your photographic images much more efficient.

As with storage of CDs and DVDs, keep your negative and transparency files stored in a safe, dry location, away from direct sunlight. Make additional copies of your filing charts in addition to storing them on your computer.

FILE NUMBER	DATE	SUBJECT/DESCRIPTION/ JOB NUMBER	NUMBER OF SLEEVES	BINDER

FILE NUMBER	DATE	SUBJECT/DESCRIPTION	CONTACT SHEET NUMBER	BINDER

Problems in Managing Your Business

No business runs so perfectly or smoothly that there's never a problem, but the manager who works to anticipate problems is usually able to sidestep them and keep on course with a minimum of hassles and hardships.

So what kinds of problems might the home-based photographer face? Potential problems can occur with vendors, customers, and possibly business associates. Your business vehicle, photography equipment, and office equipment can give you trouble. You can have financial, legal, and operational difficulties. You can have insurance problems, tax issues, and minor irritations or major worries over bookkeeping, phone and Internet service, or time management. With the right attitude and focus, you can keep potential catastrophes contained. Understand that running a business is mainly a matter of encountering, identifying, and solving problems, big and small. Most of what we've covered so far in this book has to do with managing minor problems and avoiding major ones.

Good communication skills will help you stay focused and articulate your concerns to help solve problems. Very often miscommunication is the root of a problem. Make sure you are always clear and upfront with anyone you deal with related to the function and flow of your business.

Productivity

Productivity is what your business is all about, so you will have to keep track of it, manage for it, and improve it in any way you can.

Many businesses, especially the larger ones, use reports to analyze and manage productivity. Although managers often custom design reports for specific purposes, some of the more generic reports contain information that allows experienced managers to track productivity.

Profit-and-loss (P&L) and cash-flow reports are two you can use to analyze your productivity (for more information about these reports, see Chapter 3, "Financial Planning"). These reports will be more beneficial after you have been in business a couple of years. As you begin your business, keep track of income and expenses. You don't need a chart to analyze if you are busy and work is coming in or not. If work is not coming in, you need to create ways to generate more income. We will discuss marketing strategies in Chapter 10, "Marketing Your Photography Business."

Business Communication

Communication skills are incredibly important for anyone involved in business. Keeping up with communications in a small business may be more of a challenge, however, because you are the sole representative of your business. Thanks to the Internet, the potential for business communication has increased tremendously over the past few years. You can now connect with a much wider audience than ever before. But basic communication needs are still important and need to be addressed. I will cover creating a Web site in Chapter 10, "Marketing Your Photography Business," which you should seriously consider for your home-based photography business. But before you consider creating a Web site, you need to get started with the traditional paperwork to represent your business.

Business Cards and Letterhead

Your first order of business should be to design and print an attractive business card and letterhead. You can design and print these yourself on your computer or have a small quantity printed at a local printer to get you started. Printing prices vary, and there are a lot of online printing services to research. If you can, try to support other local small businesses—it is good for your own business.

Your business card should list all your important contact information (including your Web site address), and you should have a supply of cards on hand at all times. If you don't have a Web site yet, do not wait until you create one to print your business cards. Create and print business cards even if you know you will need to change or add information later, as this is relatively easy and inexpensive to do.

A business card is just one tool to help you spread the word about your business. A letterhead that has a similar look to your business card is helpful to keep your presentation professional.

If you want to create an identity for your business, create a logo that will appear on all your promotional materials: business cards, letterhead, invoices, Web site, and any other materials related to your business. If you are not good in this area of design, connect with a graphic designer who can assist you. You should keep the logo design simple.

Work Journal

One way to keep track of business communications is to create a work journal. This could be as simple as a notebook that you use in addition to your to-do lists. You can

keep track of whom you have contacted and any plans and thoughts on what the next steps for each of those contacts may be. This journal can be used as an ongoing reference if you need to refer back to business contacts you have made or may have forgotten about. The journal can also be used to write down ideas for specific marketing plans or other upcoming projects.

Be Prompt and Courteous

Promptness is the mark of a professional; courtesy is the mark of a person who is pleasing to deal with. So in all your communications, be prompt and courteous. See to all business correspondence in a timely fashion, and return phone calls and e-mails within twenty-four hours if possible.

Follow-Up

Follow-up is essential and should be timely, but don't make it more complicated than it needs to be. Simply follow up and keep track of any correspondence you have with clients, associates, and vendors, especially if you are dealing with outstanding invoices. Use your daily work journal to date and keep track of daily follow-up needs and accomplishments. In addition, create a separate file or folder for follow-up. The file or folder should contain all the information you need to accomplish a successful follow-up.

10 Marketing Your Photography Business

Marketing is your ultimate business purpose; it means promoting and selling yourself and your services. Marketing encompasses every aspect and activity of your home-based business. All your purposes and efforts should combine to create a process that transfers goods and services to the consumer. First, last, and always, your business is marketing.

Creating a Marketable Reputation

The magnitude of the marketing effort surprises many start-up entrepreneurs. It's a big and important job that takes a lot of time and effort, especially in the beginning. Much of it amounts to building a sound and salable reputation, then researching and locating potential clients. During the early stages of your business, all this might consume more than half your time.

No matter what sort of photographic service you're engaged in, your most important product is professionalism. You must establish a reputation for reliability, competence, punctuality, courtesy, superior services, meeting deadlines, and guaranteed satisfaction. One of the ways to communicate this professionalism is through your Web site. If you do not have one, seriously consider creating one as top priority to your marketing plan.

The Importance of a Web Site

Computer technology has changed the home-based business owner's opportunities for marketing and promotion. That's because the computer has, in many ways, replaced traditional phone books and Yellow Pages. Most people now use their computers or handheld devices to search information online. That's why having a Web site to promote your photography business is so vital

today. Even if you want to target only a local consumer base, an online presence will help potential clients locate you.

The quality of your Web site is extremely important. Take time to create an effective site within your budget. With so many sites to look at, you want your Web site to have an impact or catch people's attention right away. After all, you have only a few seconds to do this—so keep it simple and appealing. Make sure the time, effort, and expense you invest in creating your Web site pay off.

Creating a Web Site

The development of Web sites has evolved over the past few years. Professional Web sites were at one time expensive to create, some costing as much as $8,000. For the small business owner, investing in a Web site may not have been a consideration. More recently, some people have been experiencing difficulty in updating their original Web sites. Either they cannot find the original designer to make changes or it is extremely costly to have someone else make the changes for them.

For these reasons, the recent trend in Web site design and maintenance is for the Web site owner to have more control over the process and have the ability to make changes when desired or necessary. Embrace this control, and create the best Web site you can for your business.

As with every area of your home-based photography business, you need to do your research before you create a Web site. Spend time exploring a variety of sites. Take notes on what designs appeal to you, what you find irritating (like how long it takes to upload a site), or what features you find helpful. Look at different photographers' Web sites, along with other areas of interest. For instance, if you are interested in wedding photography, look at wedding photographers' Web sites along with sites related to other aspects of the wedding business, such as wedding venues in your area, bridal shops, floral designers, and caterers. This will give you an idea about how others represent themselves online. Your research will be a learning process. It will help you articulate what you like and what doesn't work for you. You will then have a place to start when you are ready to create your own site.

Keeping your Web site current and looking fresh and appealing will draw viewers to your business and back to your site. You might consider working with a designer to create your Web site. He or she can show you the ropes and teach you how to manipulate your site when you want to make changes. Or you could pay an additional fee to have that person make updates and changes for you.

Web Site, Blog, or Both?

You have choices when it comes to how you'd like to format your Web site and share information. You have the option to create a Web site, a blog, or a combination of the two. Consider all three of these options before thinking about the design and layout for your site.

A Web site is organized by content, much like a book, with sections designated for specific purposes similar to chapters. Within your Web site you can create headings for such things as your portfolio, information about your business, your contact information, and your biography. You can structure your Web site into whatever categories best represent your business. Within each category you can create Web pages that offer information and images to further articulate and display what your business can offer.

A blog is a Web site organized by time; it's structured like a diary. The word *blog* is short for "Web log." The entries in a blog are arranged in reverse chronological order, so when someone comes to your blog, they see your most recent entry first. Blogs have become a popular venue for sharing information to a wide audience. For a business Web presence, however, having just a blog may not be enough for you to fully share what you have to offer in your business.

You can also create a Web site that has a blog section. Because Web sites are static and updating them can be time-consuming, the addition of a blog to your Web site can allow you to more easily keep information fresh and current. In the blog section of your Web site you could share additional information about projects you are working on, thoughts on a subject that interests you, or possibly information about a lecture you just attended. Your blog could be about any topic, but I suggest you keep it relevant to your Web site and focused on information that will further the growth of your business.

Your Web Site Design

Your Web site is your online professional representation. When you create a Web site, you are creating the foundation for your overall marketing campaign. The purpose for most of your marketing is to draw new clients to your business and to keep in contact with previous or present clients. Ultimately, you want them to contact you directly and not just look at your Web site. Therefore, you want the overall design of your site to be professional, engaging, and easy to access and navigate. Always make sure your contact information is clear, concise, and easy to find.

When it comes to designing a Web site, you can do it yourself or hire a Web designer or Web design company to create and maintain your site. If you search "Web site design" online, you will come up with many options. Before you decide what to do, however, consider what your budget will allow, with the understanding that this is a valuable and important investment into your business. Even if you want to create your own site with templates and information you find online, make sure your final site is appealing and professional looking. You do not want potential clients to be turned away because of a weak Web site. No matter what your budget allows, make sure it represents your work.

If you have extra time, patience, and technical skills, think about creating your own Web site. It can be as simple as one page that has your contact information and possibly a brief statement about your business. This is basically an updated version of the Yellow Pages; people can find you and get the information they need to contact you.

Hiring a designer to help you create your Web site is another possibility. The cost for a designer varies by region and experience. The overall price for a design package often ranges between $1,000 and $3,000. Once again, do your research and ask around. Find a designer you are comfortable with, as creating your site should be a collaborative effort. Check out his or her portfolio to see if he or she has any experience developing Web sites for photographers. Also be sure to check out all references. If you find a designer you trust who understands your business and has an excellent sense of design and technical skills, it may be worth the investment. Remember: This is a major part of your initial marketing and advertising campaigns.

There are also excellent Web design services you can explore, such as liveBooks (www.livebooks.com). These services offer customized design packages and have extensive experience working with photographers. Most Web design services have a full range of packages to offer. If you choose to work with a Web design service, compare services for the quality of their sites, their costs, and the support they offer in assisting with maintaining and updating sites.

If you are considering a Web site with a blog, you may want to look into WordPress (www.wordpress.org). WordPress is a Web site–building system originally designed for building blogs. It offers hundreds of free professional templates that you can customize. This format is ideal for nontechnical Web site owners. If this interests you, you may want to find a Web designer who is familiar with this free service to assist in creating and setting up your site.

Domain Name and Web Host

Your domain name is basically your Web site address on the Internet, and a Web host is a service that provides you with Internet access so that you can have your site on the World Wide Web.

There are online resources you can use to research possible domain names. One popular resource for finding a domain name is Go Daddy.com (www.godaddy.com). You can use this service to purchase your domain name and build and host your Web site. It is often advised that you purchase your domain name from the same service that will host your Web site. There are a variety of other Web-hosting services you can research, as well.

There are a few things to consider in choosing a domain name. For one, you will need to search and investigate what names are available to purchase. When you buy a domain name, you purchase the exclusive right to use that name on the Internet. Your domain name is how people will search for and find you on the Internet, so you want to make it as simple and as related to you and your business as possible.

When you search for a domain name, you will begin by seeing if any of the names you are considering are available. Start with your name and your name with the word *photo* or *photography* attached to it. You may discover that someone else has your name and has already purchased the rights to use this domain name. For example, here are some possibilities for researching domain names:

www.sallyjohnphotography.com

www.sallyjohnphoto.com

www.sallyjohnstudio.com

www.sjohnphoto.com

www.sjohnstudio.com

www.sjphoto.com

When you find an available domain name that you know will direct people to you and your business, buy it. You may purchase the rights to three or four domain names to secure that space on the Internet. Make sure when you or your designer sets up your Web site that all your domain names connect to your one site. You only need to give out one Web site address on your business card or any promotional information. The additional domain names are for maximizing your Internet search potential. For example, say someone is searching for a photographer and one of your domain names comes up. When the person clicks on the domain name, he or she will be connected to your Web site, even if your domain name is different from the one the person clicked.

The purchase of a domain name usually comes with a renewable yearly fee. The cost will vary from $6 to $10 per domain name, depending on the source you purchase your name from.

Web Site Content

The information you include on your Web site should give an overview of what your home-based photography business offers. Your goal is to make a connection with potential clients.

Your site should be clearly formatted so it is easy for visitors to navigate. Try to keep the overall design simple and clean. Make sure your images represent your work, but do not give it all away on your site. You want to save some of your most awesome images for your portfolio so when you meet potential clients in person, you will have something to wow them with.

The contact page on your Web site is very important. Make sure the information is accurate and clearly presented. Since you are working out of your home, think carefully about which phone number to use for your business. I suggest you *do not* use your home number. Instead, use your cell phone or another phone line dedicated for your business. And do not list your home address as your business address on your Web site. Protect yourself by sharing only enough information for people to contact you via the phone or e-mail. If you have a P.O. box, include that on your Web site.

Publicity and Promotion

Publicity is one kind of advertising money can't buy. Advertising is a concentrated and focused effort that you pay for and exercise some control over. You can and should guide publicity and control it as best you can. Publicity has the same goal as advertising—to get your business known and recognized by potential clients or customers—but is accomplished in different ways. Good publicity is far more valuable than advertising for the very fact that it isn't paid for. Consequently, it seems more like unsolicited endorsement, which it often is.

It's important to get your name before the public at every opportunity. As with advertising and an effective marketing plan, the greatest effects of publicity are cumulative, so it's equally important to keep your name and business image prominent and visible to potential clients.

One of the best tools to assist you with your publicity and promotional goals is your computer, including your e-mail list. The e-mail list has replaced the Rolodex or

address book for making contacts. Whenever possible, get an e-mail address from clients and potential clients. Use this available technology to help get your name, business, and marketing information out to the public.

E-mail Marketing

In creating your business plan and setting yearly goals, you should also include an e-mail marketing plan. The Internet is widely used in promoting businesses. And now that you have set up your Web site and established a presence on the Internet, you are ready to use this technology to promote your business.

Consider creating an e-mail marketing campaign, one that is simple to create and send without much cost and effort. Use your e-mail list and research businesses and organizations you may want to target for this campaign, and then create a list of potential clients. There are also e-mail marketing services such as Constant Contact (www.constantcontact.com) that can assist you with sending out e-mails to your list. These types of services will also track information about who may have deleted your e-mail, who opened the e-mail, and who may have followed through and connected to your Web site. As with any service, there are fees. The data provided from a service such as this can provide you with information you may want to access with follow-up or future marketing campaigns.

Organizations

Organizations and associations can help you promote your business in a variety of ways. For one, joining an organization or association is a way to get your contact information listed, possibly on the Internet, including your phone number and Web site for just the cost of membership. National professional and business associations can also offer helpful hints and provide a useful exchange of ideas. And associating with your peers across the nation can lead to important business contacts. (For a list of associations, see the Source Directory, under "Associations," at the back of this book.)

Local business, fraternal, and other organizations can do much to publicize and promote your business and put you in touch with people you need to know—prospective clients or business associates. I met and got to know both my attorney and my insurance agent when we three worked as committee members for a local chapter of a national conservation organization. I made other significant contacts through the same association. Donating my time and work to the organization also got my business a good bit of publicity.

Media Publicity

When it comes to media publicity, think outside the box. Use available technology and make connections with newspapers, online newsletters, organizations, and local radio and cable stations. Utilize the media for publicity whenever possible. After all, it is basically free advertising. If you decide to include a blog on your Web site or to create a separate blog, this too can be an avenue for publicity.

Your publicity can be as simple or as grand as you want it to be. Just be sure to put effort into creating a reason for sharing this information and making the connections. You may have an event you are promoting, such as an exhibition of your photography at a local gallery. This is an excellent opportunity to contact local media to promote your work. Contact newspapers, magazines, and possibly radio stations. However, always be sure to give them plenty of lead time to publish or contact you for further information if needed. Remember always to include your phone number, e-mail address, and Web site on all your correspondence.

Social Networking

Another form of publicity, promotion, networking, and connecting to potential clients is through online social networking sites such as Facebook, MySpace, LinkedIn, and Twitter. Social networking sites are where you can share information about your business, interests, thoughts, and contact information to an online community. They also allow you to connect with other people with common interests. Because your goal is to use this technology to help promote your business, be sure to link your Web site or blog to your social-networking connections.

If you are going to use these forms of networking for your business, be sure you have the extra time in your schedule to keep up with them. If you are going to use social-networking media, stay focused on your goal and don't waste your valuable work time unnecessarily. Also, be careful about the personal information you share.

These days, millions of people of all ages connect with online social-networking services. You may be fortunate to connect with other photographers with similar interests in another part of the country or reconnect with associates you may have lost touch with. If used to its best potential, these networking opportunities can draw viewers to your Web site and help promote your business.

Facebook started as a social-networking platform for college students and has drastically expanded to all ages. Now you can use it as a marketing tool to help promote your business. You can customize your page and control whom you allow

to view your information. For example, you can create a Facebook page just for your business and have a "fan" page, which helps build your online exposure. Remember, however, that if you use a Facebook page to promote your business, you will have to update your page on a regular basis in order to keep drawing viewers back to your page.

MySpace was one of the earliest social-networking sites. It started with a strong connection to the music industry. MySpace differs from Facebook in that anyone can view your MySpace page.

LinkedIn is the leading social-networking site for business professionals. It helps professionals get and stay connected and network with one another.

Twitter is a social-networking service that allows you to share and read what others are doing. You are able to send messages known as "tweets." Tweets are text-based messages of up to 140 characters. Twitter is more for immediate information. This may not be the most effective social-networking service to help promote your home-based photography business. However, using Twitter might be a good way to promote certain individual events, such as a gallery opening and exhibition.

If you are interested in exploring these social-networking options, consider the time they may take to maintain, what type of information you are interested in sharing, and which one(s) would best serve your needs.

Public Relations

However you can get the word out about your business is worth the effort. Make sure, however, that you keep a clear focus and maintain your integrity. You want to share information that will create an interest in your photographic work.

You can create good public relations in a variety of formats. As discussed, you can use the Internet via your Web site and/or blog or social-networking venues to promote yourself. But utilizing print media, along with possibly radio and television/cable networks, is another option.

News releases differ from the kind of publicity discussed earlier in that you furnish the copy to the media. You generate the story, either by writing it yourself or by hiring someone else to write it.

There's nothing wrong with writing your own news releases, providing you possess the necessary skills. Some editors will use your releases with little or no modification. Others might follow up to augment the material you furnish. Still others might assign a reporter and photographer to do a feature or picture spread.

Even if there's nothing particularly unusual or exciting about your business, you can still use public relations to your advantage. Special events, awards, and honors are always good news that you want to promote. In addition, news releases are a good way to get out information about an event that you may be involved with photographically. The bottom line is this: Anyway you can incorporate information that will be directed back to you and your business is good public relations.

News-Release Format

The news release should be accompanied by a cover letter that includes all your contact information—business name, address, phone number, e-mail address, and Web site address—and incorporates your logo. The cover letter should briefly describe what importance the news release focuses on so you can grab their attention.

News releases should follow a standard format that includes all pertinent information. Make sure your business name, address, phone number, and e-mail address appear prominently at the top of the news release page. The words *News Release* should also appear in large boldface type near the top of the page. Also include the current date, length, release date, and name and phone number of the person to contact for further information.

For releases going to print media, provide the length as an approximate number of words. It's best to keep them brief, usually no more than two hundred to three hundred words, never more than five hundred.

Releases for the electronic media should be shorter yet, with the length expressed in seconds. You'll have to read them aloud at a normal broadcast pace, and time them. Try to confine them to thirty seconds. You can also provide several versions of the same release running different lengths—say, twenty, thirty, and forty seconds. The recipient can then pick whichever one fits an available time slot.

The release date can be the same as the date you prepared and mailed the release or some later date, tied to an event. Your release might have a limited life or time span, which you should indicate on the release date line. For example, if the release should run only during the month of July, the release date should be July 1 through July 31.

Below the information lines, immediately preceding the text of the release, center a title, headline, or description of contents.

If a release requires more than one page, all pages except the first should be numbered sequentially and should carry an abbreviated title at the top. At the

PHOTO IMAGES UNLIMITED

1492 Columbus Drive ▪ Moon Valley, IN 54321 ▪ Phone: (123) 555–4545 ▪ Fax: (123) 555–6767
E-mail: sallyjohn@homenet.com Website: www.sallyjohnphoto.com

NEWS RELEASE

TO: _____ **DATE:** _____

_____ **LENGTH:** _____

RELEASE DATE: _____

CONTACT: Sally John, Owner/Manager

Title, Headline, or Topic

(more)

bottom of every page except the last, enclose the word *more* inside parentheses. At the end of the text, two lines beneath the final paragraph, center the words *The End* or the symbol # # #.

Use simple sentences and short paragraphs. Avoid jargon and technical language. Use what's known as the inverse-pyramid style, in which you attempt to put all the essential information into the first paragraph or two and the least important material toward the end. That way an editor can trim it from the end to accommodate space limitations.

Remember the five W's and the H—Who, What, Where, When, Why, and How—and make sure every release answers each of those.

Showing Your Work

The more people who see your photographs, the greater the cumulative effect and the better the likelihood that potential clients will think of you when they need the services of a competent photographer. So you must take advantage of every opportunity to publicize your photography.

The obvious places to display fine prints are galleries and museums, but there are other places too many photographers overlook. Of course you should try to display or sell your work to galleries, and you should enter your photographs in exhibit competitions. Talk to gallery owners about handling your work and museum curators about sponsoring one-person shows.

Any business or institution with a lobby, great hall, waiting room, or reception area is a potential client or displayer: banks, libraries, movie theaters, coffee shops and cafes, specialty shops, yoga studios, hospitals, doctors' offices, law offices, executive offices, nursing homes, retirement facilities, senior centers, day care centers, restaurants, hotels, motels, bed-and-breakfast inns, or resorts. Make sure that you target a population that will provide potential customers. If your focus is family and children's portraits, think about where families go in your area. Potential locations for displaying your work could be the library, day care centers, coffee shops, community centers, and children's specialty shops. These would all be viable places to show your work and leave a stack of business cards, especially before the holiday season. Even if you do not display your photos, leave your business cards or brochures at these locations (ask permission first, of course).

A growing area for displaying artwork is hospitals. If this interests you, check out your local hospital to see if they are displaying artwork. If not, why not propose an

idea about creating an exhibition for their lobby area or halls? Artwork can create a healing environment and is usually well received by patients, caregivers, and staff. Be creative with possibilities in showing your photography.

Donating Your Work

Making donations to local fund-raisers also can net you some promotional rewards. Depending on the nature of your photography, you might donate a portrait sitting, gift certificate, or framed print.

When a local nonprofit organization sponsors a fund-raising dinner, auction, or sale, the press is sure to cover the event, and you can share the promotional value when you are listed as one of the donors to the cause. This is great publicity. Sometimes, especially when you are starting to get your name out into the community, it is worth the donation of a print or photo session. The more connections you build, the more people will get to know what you and your business have to offer.

Volunteering Your Time and Skills

Volunteering is another way to reap the rewards of publicity. You can volunteer to cover events sponsored by local nonprofit organizations. The organizations will be grateful for your help, and local media will be glad to run your photographs with credit lines.

If you can teach what you know about photography, offer to teach a one-day or weekend photography workshop through a local organization or government agency. Such a workshop will call for advance publicity in the form of newspaper articles and public-service announcements on radio and television.

Networking

Social networking on the Internet is valuable publicity, and having a Web site is important for people to find you and learn more about what your business has to offer. There is no doubt that this technology has made incredible advances in how business is conducted. But you still need to get out and make personal connections. Simply put, nothing can replace person-to-person contact.

Networking is a way to build connections. It can be simply going out and introducing yourself to local businesses. And if an interest is created, you can set up an appointment to bring in your portfolio and show your work. When you are out and about in the community, always have business cards or brochures with you that

you can leave with contacts. You never know who you may bump into who needs a photographer or knows someone who is looking for one.

Your Portfolio

You are the best representation of your business, and your portfolio is one way to showcase your work. Most prospective clients will want to see samples of your work before they hire you. Do not rely solely on your Web site as a final portfolio. The images on your Web site should be some of your best, but keep a selection of photos only for your portfolio. You want your portfolio to have a positive impact on prospective clients.

Be sure your portfolio presentation is clean, appealing, and easy to move through. Keep your selection down so you do not overwhelm the viewer. Also never make any excuses for a photograph in your portfolio. If you feel you need to make excuses for a photo, then it should not be in your portfolio in the first place. Every photo should hold its own and have a place within the entire selection of images. You can also tailor your portfolio to the client. If you are showing your portfolio to a client who is looking for a wedding photographer, for example, you may not want to show that person your photos of antique cars. Keep the work in your portfolio relevant to the viewer.

There are a variety of professional portfolio cases and materials available to choose from. Think about how you want to present your work, and then research what would work best for you. See the Source Directory, under "Direct Sales Outlets: Photographic Equipment and Supplies," for companies that might have information about portfolio supplies and options.

After you have met with a prospective client and shared your portfolio, make sure to follow up with an e-mail, letter, or thank-you card.

Mounting, Matting, and Framing Photographs

After all the time and effort you put into creating your photographs, be sure you put the same amount of care into the final presentation of those photos. Mounting, matting, and framing photos take time, effort, and additional expense. There are once again options for you to consider. The expenses can add up quickly if you are going to hire a professional framer to take care of your framing needs. It's possible that you can learn how to do your own framing and set up a framing area in your work space. Be aware, however, that this requires care, patience, materials, and tools specifically for framing.

You may be able to find someone in your area that has a home-based framing business, and you can try to negotiate a reasonable deal for framing your photos. Once again, this could be a networking opportunity, as you could support each other by recommending work for one another.

Advertising Your Business

As you begin your home-based photography business, you should consider some kind of advertising campaign. An advertising plan for the start-up home-based photography business is a program that relies primarily on self-promotion, publicity, public relations, and limited advertising. You must determine first what advertising avenues are available in your community or working area and then which ones will serve you best. The most important reason to advertise is to get the information out to the public and potential clients that are ready to do business.

Advertising Media

Advertising takes many shapes and shows up in a variety of places, from the covers of matchbooks to the sides of buses. The media that photographers use include Web sites, newspapers, magazines, brochures, direct mail, e-marketing, and specialty supplements. Costs vary widely, as does effectiveness, and each form has its advantages and disadvantages.

- Web sites. Years ago you may have seen Yellow Pages at the top of this list, but most people today search for services online before or instead of picking up a phone book. Your Web site is one of the most important avenues of advertising. This will also connect you to vast social-networking potential if you choose to participate.

 Advantages: Once you have created your site, it works for you twenty-four hours a day, seven days a week. You will need to make the initial investment, as discussed, but it will be a wise investment.

 Disadvantages: You will need to update your Web site to continue to draw potential clients back. The initial cost may be more than you can afford. Have a plan to include some type of Internet advertising into your advertising budget.

- Newspapers. The larger the newspaper's circulation, the greater the potential effect of its advertising but also the higher its advertising rates will be. Newspapers remain among the most-used media for local advertising.

Advantages: Newspapers have a high degree of reader acceptance. Ads are available in a great variety of sizes and can be clipped and saved. They can include as much detail and information as you want or can afford.

Disadvantages: Newspaper ads are relatively expensive. Newspapers are a passive medium and are short-lived (soon discarded). Newspaper circulation has decreased, and some newspapers have gone out of business. Poor reproduction, a problem at many small newspapers, can spoil photographs you use with your ads.

■ Magazines. Under the right circumstances, magazine advertising can be effective for certain photographic businesses. Rates are high, often prohibitive, even in some city and regional magazines.

Advantages: Reproduction is usually superior to that in other print media. Target marketing is most precise. You can include as much detail as you wish, and ads can be clipped and saved.

Disadvantages: Magazines usually have long lead times for deadlines. Like other print media, they are passive and are often so cluttered with ads as to encourage readers to skip them.

■ Brochures. Brochures can be an effective form of advertising. You can tailor your brochure to articulate whatever area of photography you want to highlight.

Advantages: Brochures provide the greatest amount of space for detailed information. They offer the opportunity to showcase your photographic skills and can function as a portfolio. You can use brochures to reach a targeted direct-mail market.

Disadvantages: Brochures are expensive to produce. They can be time-consuming and expensive to distribute.

■ Direct Mail. Advertising by mail can cost in money and time, but with the right client list and selective mailing, it can be a valuable marketing tool.

Advantages: Direct-mail campaigns can reach a broad or concentrated market, depending on your needs and approach. This is also an ideal way to distribute brochures to your target markets and to encourage repeat business.

Disadvantages: Response rates are often low. Postal rates and printing costs continue to rise to levels that are often prohibitive.

- E-marketing. Creating a marketing plan to send out to e-mail addresses can be effective if organized and targeted to the appropriate audience.
 Advantages: There are no printing or postal costs. It saves paper and can easily be done on your computer.
 Disadvantages: You may need to enlist the services of an e-marketing service to assist you in sending out mass e-mails and tracking the responses. You will have to create an e-mail list of potential clients or purchase one from an e-mail list service. These extra costs could make up for traditional printing costs.

- Specialty Supplements. This category includes all the supplements periodically printed and inserted into newspapers; they are usually related to the season. Depending on your photographic services, these supplements may be worth looking into.
 Advantages: You can target your market, and the advertising will be focused on a particular subject, such as weddings, gardening, holidays, or health.
 Disadvantages: Space for advertising in supplements may be costly and limited. You may not have a choice on placement for your advertisement.

The Best of All Advertising

The best advertising is another kind you can't buy. It grows out of your reputation and is spread by people who know your work and freely recommend it. It's often called *word-of-mouth* advertising This type of advertising is created from your hard work, quality of your product, integrity, good communication skills, and personal approach with customers. It could take a few years to build your reputation, but this is an attainable goal for you and your business. Once you have established the ability to create word-of-mouth advertising, you may be able to reconsider how you invest your advertising dollars. This kind of "free" advertising makes it worth the effort to provide a consistent quality of work and service to your clients.

A good example of this is with wedding photography. Once you take photos for a bride and her family and they are pleased with your work, chances are they will recommend you to their friends and family members or perhaps use you again for another wedding. Repeat wedding work in a family is great for your reputation and creates a connection between you and your client. It adds a deeper personal touch to the whole experience for both you and your client.

This kind of word-of-mouth advertising could last a few years, as long as your clients have friends and their friends have friends. I have made some of the nicest connections with clients I have met by either photographing their wedding or one of their children's weddings. With one family, I am getting ready to photograph the third sister's wedding. So I am already familiar with at least one side of family and friends at this wedding. Word of mouth is golden. Never underestimate the power of this type of advertising.

Developing New Products, Services, and Markets

Your business will probably eventually grow to a point of saturation, either yours or the market's. When that happens, you may or may not wish to keep expanding. If you're comfortable with the size of your business and income, your marketing effort can then be reduced to maintaining the status quo and replacing markets that fall by the wayside. By then your reputation might even be such that your business won't need much publicity, promotion, or advertising.

During your business's formative years, or possibly even for the life of your business, you'll need to be concerned with continued growth and increased profits. If you are managing wisely and getting as much as possible out of every dollar you earn and spend, you will need to turn your attention to developing new products, services, and markets as ways of increasing income and profits.

Identify Your Opportunities

No matter what kinds of photography you do, you'll discover other products and services you can provide and a great number and variety of potential new markets. Before you venture into new areas, though, you need to consider carefully the kinds of work that interest you, the kinds that don't, and those that are of marginal interest. You need to identify and analyze the markets as well. It's equally important to know and understand your limitations.

When a wet winter put an end to a two-year period of drought where I live, filling coastal lakes and reservoirs and leaving a deep snowpack in the mountains, I prepared for a busy spring. When the weather was right, new foliage was greening hillsides and meadows, and wildflowers were popping up everywhere, I packed my gear and went waterfall hunting. That spring I managed to build up my stock of waterfall photographs significantly and have continued to do so as wet winters have permitted.

Even more specific yet is my notation "Skunk Cabbage." I already have a fair file of pictures of skunk cabbages, interesting plants that are related to the calla lily that grow in some profusion in coastal lowlands. Several summers ago, I found a huge, sprawling patch of the plants with leaves as broad as three feet. But the photograph I want must be shot in the late winter or early spring, when the plant's cheery spathes unfold and paint the verdant valley with ten thousand broad brushstrokes of bright yellow. That's also the shot that will complete a picture-story I'll sell to a magazine. If I have a good day, I will also collect stock shots and other images that will sell to calendar and postcard markets.

Government Work

Don't overlook the possibility of working for various government agencies that regularly buy work from freelancers or independent contractors. Potential markets exist at all levels of government: city, county, state, and federal.

City and county park and recreation departments are good prospects, as are port authorities and any agencies engaged in promoting tourism.

On the state level are colleges and universities, which publish brochures, catalogs, and other photo-illustrated materials. State departments and divisions that frequently use photographs include fish and wildlife, forestry, ecology, tourism, parks, transportation, agriculture, and economic development.

The sprawling federal government has many departments, bureaus, and services with headquarter offices in Washington, D.C., and with field offices in all the states and many cities, large and small. Some of the most widely represented agencies include the U.S. Fish and Wildlife Service, National Park Service, and USDA Forest Service.

Even in the small community where I live, we have large Bureau of Land Management and U.S. Coast Guard facilities, as well as offices of the U.S. Army Corps of Engineers, the National Marine Fisheries Service, and the Sanctuaries and Reserves

Getting Started

- Decide to start a home-based photography buisness. You have the drive, organizational and time-management skills, photographic experience, and some finaces to get started.

- Create space in your home for your new photography business.

- Purchase photography equipment.

- Purchase computer equipment.

- Purchase office supplies.

- Set up your filing system for your photographs and business.

- Attend to business, forms, and necessary permits and tax information, if needed.

- Create a Web site.

- Promote your business. Get the word out!

- You are ready to get started. Congratulations!

Division of the National Oceanic and Atmospheric Administration, for which I have worked as an independent contractor.

The Show Must Go On—and On and On and On

At times, I have saturated various markets, especially some of the smaller ones. For example, I have sold so much material to a particular publication or category of publications that I've had to back off for several months to a year to let them use up my material in their inventory.

During tight financial times, some markets just go out of business, which can leave you high and dry if they represent a substantial part of your income, especially if you don't have alternative markets to fall back on. Some years ago I was not prepared for three of my magazine markets to fold in May and June, at the peak of my most productive time of the year. While I hustled to develop other markets to fill the void and regain my momentum, I lost a good bit of valuable time and income.

I have learned from such experiences that I must continually strive to develop new markets and improve existing ones, but too often I have so much work that I don't have time for that crucial part of my operation. All I can do then is promise myself I will do better when the pressure is off.

Toward that end, I make only one New Year's resolution and repeat it every January 1. I have it printed in bold black on an index card pinned to the bulletin board above my desk. It says simply: WORK SMARTER THIS YEAR!

Ten Ways to Expand Your Photography Business

1. *Model portfolios.* Models need photographs of themselves to present to agencies and potential clients. You can charge as you would for portraits or location shoots, or if you need models in your work, you can trade your photographic services for model services.

2. *Actor portfolios.* Actors, dancers, and other theatrical artists also need photographs of themselves. Look for prospective clients at local production companies and college or university dramatics departments.

3. *Artist portfolios.* Artists in all media need to keep photographic documentation of their works; often they don't have or don't take the time to do so. Sell your services to them and you will probably get a good bit of return business.

4. *Limited-edition fine-art prints.* Select from your files photographs that lend themselves to enlargement and display. Create a series of superbly mounted, matted, and framed prints in limited numbers. Then sell them as authenticated, signed, and numbered limited editions.

5. *Advertising photographs of locally made products.* Make yourself aware of all locally made products, and remain alert for the introduction of new products. Let the manufacturers know that you are available to shoot advertising and catalog photographs.

6. *Multimedia productions for local companies.* Here's a mighty lucrative endeavor for any photographer or team of collaborators capable of producing presentations that include still photography, video, music, and narration.

7. *Surfing and sailboarding photographs.* If you live along the coast or near lakes and rivers frequented by sailboarders, you'll find good opportunities for colorful action photography that will sell to a variety of markets, including the surfers and sailboarders themselves.

8. *Photographs of athletes in action.* Action shots of athletes of all ages and levels are always in demand as publication and stock photography. You can also sell these photos to the athletes. So cover sports events in your area, and take plenty of model releases with you.

9. *Racing photographs.* Races of all sorts—auto, boat, motorcycle, dogsled— are sure bets for good action photography that will sell to local and national media, stock agencies, and the racers themselves.

10. *Framing services.* Custom mounting, matting, and framing represent an aspect of your photography business that can become a lucrative sideline. Learn the craft, and advertise your services.

Selected Bibliography

Attard, Janet. *The Home Office and Small Business Answer Book,* Second Edition. New York: Owl Books, 2000.

Chase, Larry. *Essential Business Tactics for the Net,* Second Edition. New York: John Wiley & Sons, 2001.

Covington, Michael A., et al. *Dictionary of Computer and Internet Terms,* Eighth Edition. Hauppauge, N.Y.: Barron's, 2003.

Dible, Donald, editor. *What Everybody Should Know about Patents, Trademarks and Copyrights.* Reston, N.J.: Prentice Hall, 1982.

Foster, Frank H., and Robert L. Shook., *Patents, Copyrights, and Trademarks.* Second Edition. New York: John Wiley & Sons, 1993.

Gumpert, David E. *How to Really Start Your Own Business,* Fourth Edition. Needham, Mass.: Lauson Publishing Company, 2003.

H&R Block, Inc. *H&R Block Income Tax Guide.* New York: Collier Books. Published annually.

Harper, Stephen C. *The McGraw-Hill Guide to Starting Your Own Business: A Step-by-Step Blueprint for the First-Time Entrepreneur,* Second Edition. New York: McGraw-Hill, 2003.

Hart, Russell, and Nan Starr. *Photographing Your Artwork,* Second Edition. Buffalo, N.Y.: Amherst Media, 2000.

Hedgecoe, John. *The Photographer's Handbook,* Third Edition. New York: Alfred A. Knopf, 1992.

Herring, Jerry, and Mark Fulton. *The Art & Business of Creative Self-Promotion.* New York: Watson-Guptill Publications, 1987.

Jacobs, Lou, Jr. *Selling Photographs: Determining Your Rates and Understanding Your Rights.* New York: Amphoto, 1988.

————. *Selling Stock Photography: How to Market Your Photographs for Maximum Profit.* New York: Amphoto, 1992.

J. K. Lasser Institute. *J. K. Lasser's Your Income Tax Guide.* New York: Prentice Hall. Published annually.

Murphy, John, and Michael Rowe. *How to Design Trademarks and Logos.* Cincinnati: North Light Books, 1991.

Nunes, Morris A. *Basic Legal Forms for Business.* New York: John Wiley & Sons, 1993.

Pfaffenberg, Bryan. *Webster's New World Dictionary of Computer Terms,* Ninth Edition. New York: Macmillan, 2001.

Rue, Leonard Lee, III. *How I Photograph Wildlife and Nature.* New York: W. W. Norton & Company, 1984.

Thomas, Bill. *How You Can Make $50,000 a Year as a Nature Photojournalist.* Cincinnati: Writer's Digest Books, 1986.

Tresidder, Jack, editor-in-chief. *Kodak Library of Creative Photography.* 18 volumes. New York: Time-Life Books, 1983, 1985.

Willins, Michael, editor. *Photographer's Market.* Cincinnati: Writer's Digest Books. Published annually.

Zimmerman, Jan and Hoon Meng Ong. *Marketing on the Internet,* Sixth Edition. Gulf Breeze, Fla.: Maximum Press, 2001.

Source Directory

Associations

Advertising Photographers of America
P.O. Box 725146
Atlanta, GA 31139
Phone: (800) 272-6264
Fax: (888) 889-7190
Web: www.apanational.com

American Society of Media
Photographers
150 North Second Street
Philadelphia, PA 19106
Phone: (215) 451-2767
Fax: (215) 451-0880
E-mail: info@asmp.org
Web: www.asmp.org

National Association of Photoshop Professionals
333 Douglas Road East
Oldsmar, FL 34677
Phone: (800) 738-8513
Fax: (813) 433-5015
Web: www.photoshopuser.com

National Press Photographers
Association
3200 Croasdaile Drive, Suite 306
Durham, NC 27705
Phone: (919) 383-7246
Fax: (919) 383-7261
E-mail: info@nppa.org
Web: www.nppa.org

Professional Photographers of
America, Inc.
229 Peachtree Street Northeast
Suite 2200
Atlanta, GA 30303
Phone: (404) 522-8600
Phone: (800) 786-6277
Fax: (404) 614-6400
Web: www.ppa.com

Wedding & Portrait Photographers
International
6059 Bristol Parkway, Suite 100
Culver City, CA 90230
Phone: (310) 846-4770
Fax: (310) 846-5995
Web: www.wppi-online.com

Book Publishers

Allworth Press
10 East 23rd Street
New York, NY 10010
Phone: (212) 777-8395
Phone: (800) 491–2808
Web: www.allworth.com

Amherst Media
175 Rano Street, Suite 200
Buffalo, NY 14207
Phone: (716) 874-4450
Phone: (800) 622-3278
Fax: (716) 874-4508
Web: www.amherstmedia.com

Focal Press
Elsevier, Inc.
30 Corporate Drive, Suite 400
Burlington, MA 01803
Phone: (866) 607-1417
Web: www.books.elsevier.com

John Wiley & Sons, Inc.
Corporate Headquarters
111 River Street
Hoboken, NJ 07030
Phone: (201) 748-6000
Fax: (201) 748-6088
Web: www.wiley.com

Photographer's Market
F+W Media, Inc.
4700 East Galbraith Road
Cincinnati, OH 45236
Phone: (513) 531-2690
Web: www.fwbookstore.com

Camera and Lens Companies

Bronica
(See Tamron USA, Inc.)

Canon USA, Inc.
1 Canon Plaza
Lake Success, NY 11042
Phone: (516) 328-5000
Web: www.usa.canon.com

Contax Cameras
Web: www.contaxcameras.com

Hasselblad USA
Web: www.hasselbladusa.com

HP Marketing
16 Chapin Road
Pine Brook, NJ 07058
Phone: (800) 735-4373
Fax: (973) 808-9004
E-mail: info@hpmarketingcorp.com
Web: www.hpmarketingcorp.com

Kenko
(See THK Photo Products, Inc.)

Leica Camera, Inc.
Web: www.leica-camera.com

Linhof
(See HP Marketing)

Mamiya America Corporation
8 Westchester Plaza
Elmsford, NY 10523
Phone: (914) 347-3300
Fax: (914) 347-3309
Fax: (800) 321-2205
E-mail: info@mamiya.com
Web: www.mamiya.com

Nikon, Inc.
1300 Walt Whitman Road
Melville, NY 11747
Phone: (631) 547-4200
Phone: (800) 645-6687
Fax: (631) 547-4025
Web: www.nikonusa.com

Olympus Imaging America, Inc.
3500 Corporate Parkway
P.O. Box 610
Central Valley, PA 18034
Phone: (888) 553-4448
Web: www.getolympus.com

Pentax Imaging Company
600 Twelfth Street, Suite 300
Golden, CO 80401
Phone: (800) 877-0155
Web: www.pentaximaging.com

Schneider Optics, Inc.
285 Oser Avenue
Hauppauge, NY 11788
Phone: (631) 761-5000
Phone: (800) 645-7239
Fax: (631) 761-5090
E-mail: info@schneideroptics.com
Web: www.schneideroptics.com

Sigma Corporation of America
15 Fleetwood Court
Ronkonkoma, NY 11779
Phone: (631) 585-1144
Fax: (631) 585-1895
E-mail: info@sigmaphoto.com
Web: www.sigmaphoto.com

Sinar Bron Imaging
17 Progress Street
Edison, NY 08820
Phone: (908) 754-5800
Phone: (800) 456-0203
Fax: (908) 754-5807
E-mail: info@sinarbron.com
Web: www.sinarbron.com

Tamron USA, Inc.
10 Austin Boulevard
Commack, NY 11725
Phone: (631) 858-8400
Fax: (631) 543-5666
Web: www.tamron.com

THK Photo Products, Inc.
7642 Woodwind Drive
Huntington Beach, CA 92647
Phone: (800) 421-1141
Phone: (714) 849-5700
Fax: (714) 849-5677
E-mail: support@thkphoto.com
Web: www.thkphoto.com

Tokina
(See THK Photo Products, Inc.)

Vivitar USA
195 Carter Drive
Edison, NJ 08817
Phone: (800) 637-1090
Web: www.vivitar.com

Camera Bags, Cases, Straps, and Belt Systems

Lowepro USA
DayMen US Inc.
1003 Gravenstein Highway North
Suite 200
Sebastopol, CA 95472
Phone: (707) 827-4000
Web: www.lowepro.com

Pelican Products, Inc.
23215 Early Avenue
Torrance, CA 90505
Phone: (310) 326-4700
Phone: (800) 473-5422
Fax: (310) 326-3311
Web: www.pelican.com

Photoflex, Inc.
97 Hangar Way
Watsonville, CA 95076
Phone: (831) 786-1370
Phone: (800) 486-2674
Fax: (831) 786-1371
E-mail: photoflex@photoflex.com
Web: www.photoflex.com

Tamrac, Inc.
9240 Jordan Avenue
Chatsworth, CA 91311
Phone: (818) 407-9500
Phone: (800) 662-0717
Fax: (818) 407-9501
Web: www.tamrac.com

Tenba
8 Westchester Plaza
Elmsford, NY 10523
Phone: (914) 347-3300
Fax: (914) 347-3309
E-mail: info@tenba.com
Web: www.tenba.com

Computer Companies

Ace Computers
1425 East Algonquin Road
Arlington Heights, IL 60005
Phone: (847) 952-6900
Phone: (877) 223-2667
Fax: (847) 952-6901
Web: www.acecomputers.com

Acer America Corporation
333 West San Carlos Street, Suite 1500
San Jose, CA 95110
Phone: (408) 533-7700
Fax: (408) 533-4555
Web: www.acer.com/us

Adamant Computers
Nalex
25901 Emery Road, Suite 117
Cleveland, OH 44128
Phone: (216) 360-8877
Tech Support: (216) 360-8877
Fax: (216) 360-8877
Web: www.adamant.com

Americomp
Web: www.acompinc.com

Apple Computer
1 Infinite Loop
Cupertino, CA 95014
Phone: (408) 996-1010
Phone: (800) 692-7753
Web: www.apple.com

Compaq
(See Hewlett-Packard Corporation)

Creative Vision Technologies, Inc.
2950 Xenium Lane North, Suite 134
Plymouth, MN 55441
Phone: (763) 478-6446
Phone: (888) 770-0500
Fax: (763) 478-6550
E-mail: info@cvtinc.com
Web: www.cvtinc.com

Dell USA
1 Dell Way
Round Rock, TX 78682
Phone: (800) 274-3355
Web: www.dell.com

Enpower
Web: www.enpower.com

Gateway, Inc.
7565 Irvine Center Drive
Irvine, CA 92618
Phone: (800) 846-4208
Web: www.gateway.com

Hewlett–Packard Corporation
3000 Hanover Street
Palo Alto, CA 94034
Phone: (650) 857-1501
Phone: (800) 752-0900
Fax: (650) 857-5518
Web: www.hp.com

IBM Corporation
1 New Orchard Road
Armonk, NY 10504
Phone: (800) 426-4968
Phone: (914) 499-1900
Web: www.ibm.com

InfoGOLD Corporation
1172 Murphy Avenue, #160
San Jose, CA 95131
Phone: (408) 441-8899
Fax: (408) 441-6688
Web: www.infogold.com

Legend Micro, Inc.
30700 Carter Street, Unit B
Solon, OH 44139
Phone: (440) 776-8838
Phone: (800) 935-9305
Fax: (440) 498-0706
Web: www.legendmicro.com

Micro Express
8 Hammond Drive, #105
Irvine, CA 92618
Phone: (949) 460-9911
Phone: (800) 989-9900
Fax: (949) 269-3070
E-mail: info@microexpress.net
Web: www.microexpress.net

Toshiba America Information Systems
Digital Products Division
9740 Irvine Boulevard
Irvine, CA 92618
Phone: (949) 583-3000
Phone: (800) 457-7777
Web: www. toshiba.com

Courses, Seminars, Schools, and Workshops

International Center of Photography
1114 Avenue of the Americas at 43rd Street
New York, NY 10036
Phone: (212) 857-0001
Fax: (212) 857-0091
E-mail: education@icp.org
Web: www.icp.org

Keystone Learning Systems
5300 Westview Drive, Suite 405
Frederick, MD 21703
Phone: (410) 800-4000
Phone: (800) 949-5590
Fax: (301) 624-1733
Web: www.keystonelearning.com

Maine Media Workshops
70 Camden Street
Rockport, ME 04856
Phone: (877) 577-7700
Phone: (207) 236-8581
Fax: (207) 236-2558
E-mail: info@theworkshops.com
Web: www.theworkshops.com

New York Institute of Photography
211 East 43rd Street, Suite 2402
New York, NY 10017
Phone: (212) 867-8260
Phone: (800) 445-7279
Fax: (212) 867-8122
E-mail: info@nyip.com
Web: www.nyip.com

The Nikon School
1300 Walt Whitman Road
Melville, NY 11747
Phone: (631) 547-8666
Fax: (631) 547-0305
Web: www.nikonusa.com

PhotoPlus Expo
Phone: (508) 743-8505
E-mail: photoplus@xpressreg.net
Web: www.photoplusexpo.com

Planetlearn.com
14 Lower Falls Road
Falmouth, ME 04105
Phone: (207) 671-1666
E-mail: sales@planetlearn.com
Web: www.planetlearn.com

Santa Fe Photographic Workshops
P.O. Box 9916
Santa Fe, NM 87504
Phone: (505) 983-1400
Fax: (505) 989-8604
E-mail: info@santafeworkshops.com
Web: www.santafeworkshops.com

Direct Sales Outlets: Business and Office Equipment and Supplies

Batteries.com
111 Congressional Boulevard, Suite 350
Carmel, IN 46032
Phone: (888) 288-6500
E-mail: info@batteries.com
Web: www.batteries.com

Global Industrial Equipment
Phone: (888) 978-7759
Web: www.globalindustrial.com

Hello Direct
Phone: (800) 435-5634
Web: www.hellodirect.com

NEBS Deluxe Small Business Sales, Inc.
500 Main Street
Groton, MA 01471
Phone: (888) 823-6327
Customer Service: (800) 225-9540
Fax: (866) 449-3794
Web: www.nebs.com

Office Equipment Outlet
143 East Main Street, Suite 150
Lake Zurich, IL 60047
Phone: (800) 553-2112
Web: www.oeo.com

OfficeMax
263 Shuman Boulevard
Naperville, IL 60563
Phone: (630) 438-7800
Phone: (800) 661-5931
Web: www.officemax.com

Quill Corporation
P.O. Box 94080
Palatine, IL 60094
Phone: (800) 789-1331
Fax: (800) 789-8955
Web: www.quillcorp.com

Staples
(800) 378-2753
www.staples.com

Walsh Envelope Company
813 Bethel Avenue
Aston, PA 19014
Phone: (610) 364-3150
Phone: (800) 879-2574
Fax: (610) 364-3190
Web: www.walshenvelopes.com

Direct Sales Outlets: Computer Products

CDW Computer Centers, Inc.
300 North Milwaukee Avenue
Vernon Hills, IL 60061
Phone: (847) 465-6000
Web: www.cdw.com

CompSource
3241 Superior Avenue
Cleveland, OH 44114
Phone: (216) 566-7767
Phone: (888) 266-7767
Fax: (216) 619-7117
Web: www.c-source.com

Computer Gate
2995 Gordon Avenue
Santa Clara, CA 95051
Phone: (408) 730-0673
Phone: (888) 437-0895
Fax: (408) 730-0735
Web: www.computergate.com

Computer Outlet
Web: www.compuoutlet.com

Global Computer Supplies
11 Harbor Park Drive
Port Washington, NY 11050
Phone: (800) 446-9662
Web: www.globalcomputer.com

Mac Mall
2555 West 190th Street
Torrance, CA 90504
Phone: (800) 622-6255
Web: www.macmall.com

PC Mall
2555 West 190th Street
Torrance, CA 90504
Phone: (800) 555-6255
Web: www.pcmall.com

TigerDirect
7795 West Flagler Street
Suite 35
Miami, FL 33144
Phone: (800) 800-8300
Web: www.tigerdirect.com

Zones, Inc.
1102 15th Street SW, Suite 102
Auburn, WA 98001
Phone: (253) 205-3000
Phone: (800) 408-9663
Fax: (800) 684-8080
Web: www.zones.com

Direct Sales Outlets: Photographic Equipment and Supplies

Abe's of Maine
Raritan Center
5 Fernwood Avenue
Edison, NJ 08837
Phone: (800) 992-2237
Phone: (800) 339-2237
Fax: (718) 228-8727
E-mail: info@abesofmaine.com
Web: www.abesofmaine.com

Adorama
42 West 18th Street
New York, NY 10011
Phone: (212) 741-0052; (800) 223-2500
Customer Service: (212) 741-0466
Customer Service: (800) 815-0702
Fax: (212) 463-7223
E-mail: info@adorama.com
Web: www.adoramacamera.com

B&H Photo
420 Ninth Avenue
New York, NY 10001
Phone: (212) 560-3255
Phone: (866) 264-5201
Web: www.bhphotovideo.com

Beach Camera
80 Carter Drive
Edison, NJ 08817
Phone: (732) 623-4650
Phone: (800) 572-3224
Fax: (732) 968-2283
Web: www.beachcamera.com

Calumet Photographic Pro Center
890 Supreme Drive
Bensenville, IL 60106
Phone: (800) 453-2550
Fax: (800) 577-3686
E-mail: custserv@calumetphoto.com
Web: www.calumetphoto.com

Cambridge World
Phone: (718) 858-5002 or (212) 675-8600
Phone: (800) 221-2253
Fax: (718) 858-5437
E-mail: bestdeal@cambridgeworld.com
Web: www.cambridgeworld.com

Camera World
Ritz Interactive, Inc.
2010 Main Street,
Irvine, CA 92614
Phone: (800) 226-3721
Web: www.cameraworld.com

The Denny Manufacturing Company,
Inc.
P.O. Box 7200
Mobile, AL 36670
Phone: (800) 844-5616
Fax: (251) 452-4630
E-mail: info@dennymfg.com
Web: www.dennymfg.com

Focus Camera & Video
Phone: (718) 437-8810
Phone: (800) 221-0828
Customer Service: (718) 437-8899
Customer Service: (888) 901-4438
Fax: (718) 437-8811
E-mail: info@focuscamera.com
Web: www.focuscamera.com

Porter's Camera Store
323 West Viking Road
Cedar Falls, IA 50613
Phone: (319) 266-0303
Phone: (800) 553-2001
Web: www.porters.com

Samy's Camera
431 South Fairfax Avenue
Los Angeles, CA 90036
Phone: (323) 938-2420
Phone: (800) 321-4726
Fax: (323) 937-2919
E-mail: lacamera@Samys.com
Web: www.samys.com

Electronic Flashes and Accessories

Bogen Imaging
565 East Crescent Avenue
Ramsey, NJ 07446
Phone: (201) 818-9500
Fax: (201) 818-9177
E-mail: info@bogenimaging.com
Web: www.bogenimaging.us

The Tiffen Company, LLC
90 Oser Avenue
Hauppauge, NY 11788
Phone: (631) 273-2500
Fax: (631) 273-2557
E-mail: techsupport@tiffen.com
Web: www.tiffen.com

ToCAD America, Inc.
53 Green Pond Road
Rockaway, NJ 07866
Phone: (973) 627-9600
Fax: (973) 664-2438
E-mail: info@tocad.com
Web: www.tocad.com

Vivitar USA
195 Carter Drive
Edison, NJ 08817
Phone: (800) 637-1090
Web: www.vivitar.com

Film Manufacturers

Eastman Kodak Company
343 State Street
Rochester, NY 14650
Phone: (585) 781-6231
Phone: (800) 242-2424
Web: www.kodak.com

Fujifilm USA, Inc.
200 Summit Lake Drive, Floor 2
Valhalla, NY 10595
Phone: (914) 789-8100
Phone: (800) 755-3854
Web: www.fujifilmusa.com

Ilford Photo
18766 John J Williams Hwy, Suite 4-327
Rehoboth Beach, DE 19971
Fax and voice mail: (888) 372-2338
Web: www.ilfordphoto.com

Filters, Screens, and Lens Attachments

Bogen Imaging
565 East Crescent Avenue
Ramsey, NJ 07446
Phone: (201) 818-9500
Fax: (201) 818-9177
E-mail: info@bogenimaging.com
Web: www.bogenimaging.us

Cokin Filters
Web: www.cokinusa.com

Heliopan Filters
HP Marketing Corporation
16 Chapin Road
Pine Brook, NJ 07058
Phone: (800) 735-4373
Fax: (973) 808-9004
E-mail: info@hpmarketingcorp.com
Web: www.hpmarketingcorp.com

Hoya Filters
THK Photo Products, Inc.
7642 Woodwind Drive
Huntington Beach, CA 92647
Phone: (714) 849-5700
Customer Service: (800) 421-1141
Fax: (714) 849-5677
E-mail: support@thkphoto.com
Web: www.thkphoto.com

Lee Filters USA
Phone: (818) 238-1220
Phone: (800) 576-5055
Web: www.leefiltersusa.com

The Tiffen Company, LLC
90 Oser Avenue
Hauppauge, NY 11788
Phone: (631) 273-2500
Fax: (631) 273-2557
E-mail: techsupport@tiffen.com
Web: www.tiffen.com

Magazines

American Photo
1633 Broadway, 43rd Floor
Phone: (212) 767-6000
Phone: (800) 274-4514
Web: www.americanphotomag.com

Communications Arts
110 Constitution Drive
Menlo Park, CA 94025
Phone: (650) 326-6040
Fax: (650) 326-1648
Web: www.commarts.com

Computer Shopper
Web: www.computershopper.com

Digital Photo
Werner Publishing Corporation
12121 Wilshire Blvd., 12th Floor
Los Angeles, CA 90025
Phone: (800) 537-4619
Phone: (310) 820-1500
Fax: (310) 826-5008
Web: www.dpmag.com

Entrepreneur
Entrepreneur Media, Inc.
2445 McCabe Way, Suite 400
Irvine, CA 92614
Phone: (949) 261-2325
Subscriptions: (800) 274-6229
Start-up Guides: (800) 421-2300
Web: www.entrepreneur.com

Home Business Journal
E-mail: homebizjour@starband.net
Web: www.homebusinessjournal.net

Home Business Magazine
20664 Jutland Place
Lakeville, MN 55044
Phone: (800) 734-7042
Fax: (714) 388-3883
Web: www.homebusinessmag.com

Inc.
 7 World Trade Center
New York, NY 10017
Phone: (212) 389-5377
Web: www.inc.com

Nature Photographer
P.O. Box 220
Lubec, ME 04652
Phone: (207) 733-4201
Web: www.naturephotographermag
.com

Outdoor Photographer
Werner Publishing Corporation
12121 Wilshire Boulevard, 12th Floor
Los Angeles, CA 90025
Phone: (310) 820-1500
Web: www.outdoorphotographer.com

PC Magazine
Ziff Davis Media, Inc.
28 East 28th Street
New York, NY 10016
Phone: (212) 503-3500
West Coast: (415) 547-8000
Web: www.pcmag.com

PC World Communications
501 Second Street
San Francisco, CA 94107
Phone: (415) 243-0500
Fax: (415) 442-1891
Web: www.pcworld.com

Photo District News
770 Broadway, 7th Floor
New York, NY 10003
Phone: (646) 654-5780
Phone: (800) 697-8859
Fax: (646) 654-5813
Web: www.pdnonline.com

Photographic Digital Photography Guide
Web: www.photographic.com

Popular Photography
Web: www.popphoto.com

Professional Photographer Magazine
229 Peachtree Street NE, Suite 2200
International Tower
Atlanta, GA 30303
Phone: (404) 522-8600
Fax: (404) 614-6406
Web: www.ppmag.com

Rangefinder Magazine
6059 Bristol Parkway, Suite 100
Culver City, CA 90230
Phone: (310) 846-4770
Fax: (310) 846-5995
Web: www.rangefindermag.com

Shutterbug
1415 Chaffee Drive, Suite 10
Titusville, FL 32780
Phone: (321) 269-3212
Phone: (800) 829-3340
E-mail: editorial@shutterbug.com
Web: www.shutterbug.com

Smart Computing
131 West Grand Drive
Lincoln, NE 68521
Phone: (800) 544-1264
Fax: (402) 479-2104
E-mail: editor@smartcomputing.com
www.smartcomputing.com

Multifunction Peripherals

Brother International
100 Somerest Corporate Boulevard
Bridgewater, NJ 08807
Phone: (908) 704-1700
Fax: (908) 704-8235
Web: www.brother-usa.com

Canon USA
One Canon Plaza
Lake Success, NY 11042
Phone: (516) 328-5000
Web: www.usa.canon.com

Hewlett–Packard Corporation
3000 Hanover Street
Palo Alto, CA 94304
Phone: (650) 857-1501
Fax: (650) 857-5518
Web: www.hp.com

Xerox Corporate Headquarters
45 Glover Avenue
P.O. Box 4505
Norwalk, CT 06856
Phone: (203) 968-3000
Phone: (800) 334-6200
Web: www.xerox.com

Photographic Filing and Storage Systems and Supplies

Light Impressions
P.O. Box 2100
Santa Fe Springs, CA 90670
Phone: (800) 828-6216
Web: www.lightimpressionsdirect.com

Print File, Inc.
P.O. Box 607638
Orlando, FL 32860
Phone: (407) 886-3100
Phone: (800) 508-8539
Fax: (407) 886-0008
Fax: (800) 546-4145
E-mail: support@printfile.com
Web: www.printfile.com

SlideScribe
Image Innovations
Phone: (210) 696-5900
Phone: (800) 345-4118
Fax: (210) 855-9899
Web: www.slidescribe.com

Vue-All
HP Marketing
16 Chapin Road
P.O. Box 715
Pine Brook, NJ 07058
Phone: (800) 735-4373
Fax: (973) 808-9004
E-mail: info@hpmarketingcorp.com
Web: www.hpmarketingcorp.com

Picture-Framing Tools and Materials

Alto's EZ Mat
703 North Wenas Street
Ellensburg, WA 98926
Phone: (800) 225–2497
Phone: (509) 962-9212
Fax: (509) 962-3127
Web: www.altosezmat.com

American Frame
400 Tomahawk Drive
Maumee, OH 43537
Phone: (888) 628-3833
Phone: (419) 893-5595
Fax: (800) 893–3898
E-mail: customer.service@
americanframe.com
Web: www.americanframe.com

Crescent Cardboard Company
100 West Willow Road
Wheeling, IL 60090
Phone: (800) 323-1055
Fax: (847) 537-7153
Web: www.crescentcardboard.com

Graphik Dimensions Ltd.
2103 Brentwood Street
P.O. Box 10002
High Point, NC 27261
Phone: (800) 221-0262
Fax: (336) 887-3773
Customer Service: (800) 332-8884
E-mail: customercare@pictureframes
.com
Web: www.pictureframes.com

Light Impressions
P.O. Box 2100
Santa Fe Springs, CA 90670
Phone: (800) 828-6216
Web: www.lightimpressionsdirect.com

Nielsen & Bainbridge
40 Eisenhower Drive
Paramus, NJ 07653
Phone: (800) 526-9073
E-mail: info@nbframing.com
Web: www.nbframing.com

University Products, Inc.
517 Main Street
P.O. Box 101
Holyoke, MA 01041
Phone: (800) 628-1912
Fax: (413) 532-3372
E-mail: info@universityproducts.com
Web: www.universityproducts.com

Tripods and Accessories

Bogen Imaging
565 East Crescent Avenue
Ramsey, NJ 07446
Phone: (201) 818-9500
Fax: (201) 818-9177
E-mail: info@bogenimaging.com
Web: www.bogenimaging.us

Gitzo Tripods
(See Bogen Imaging)

Kirk Enterprises
333 Hoosier Drive
Angola, IN 46703
Phone: (260) 665-3670
Phone: (800) 626-5074
Fax: (260) 665-9433
Web: www.kirkphoto.com

Manfrotto Tripods
(See Bogen Imaging)

Slik Tripods
THK Photo Products, Inc.
7642 Woodwind Drive
Huntington Beach, CA 92647
Phone: (800) 421-1141
Web: www.thkphoto.com

U.S. Government

Internal Revenue Service
Forms and Publications
Assistance for Businesses
Phone: (800) 829-4933
Web: www.irs.ustreas.gov

Small Business Administration
409 Third Street, Southwest
Washington, DC 20416
Phone: (800) 827-5722
E-mail: answerdesk@sba.gov
Web: www.sbaonline.sba.gov

U.S. Copyright Office
Library of Congress
101 Independence Avenue, Southeast
Washington, DC 20559
Phone: (202) 707-3000
Phone: (202) 707-5959
Web: www.copyright.gov

U.S. Government Printing Office
732 North Capitol Street Northwest
Washington, DC 20401
Phone: (202) 512-1800
Web: www.gpo.gov

U.S. Patent and Trademark Office
Mail Stop USPTO Contact Center (UCC)
P.O. Box 1450
Alexandria, VA 22313
Phone: (800) 786-9199
Web: www.uspto.gov

Index

About the Authors

Kenn Oberrecht acquired management skills by working for six years in the corporate world as an office manager for American Materials Corporation in Fairfield, Ohio, and as production control supervisor for General Electric Company's Large Jet Engine Division in Evendale, Ohio. He concurrently attended the University of Cincinnati Evening College, where he earned A.A. and B.S. degrees. Upon graduation, he and his wife, Pat, left for the University of Alaska Fairbanks, where he earned B.A. and M.A. degrees and later taught writing and photography courses.

While in graduate school, Kenn began working part-time as a freelance writer and photographer, selling to local, state, and national markets. After grad school, he and Pat traveled for a year in the United States and Canada, then settled on the Oregon coast in 1975, where he has run his diversified full-time home-based business ever since.

Kenn's feature articles, picture-stories, and photographs have appeared in hundreds of local, regional, and national publications, including *Alaska, Animal Kingdom, Coast to Coast, Field & Stream, Modern Photography, Northwest Travel, Oregon Coast, Oregon Times, Outdoor Arizona, Outdoor Life, Petersen's Photographic, Sea, Sports Afield, Sports Illustrated,* and *Sunset*. He is the author of thirty books and revised editions, including *How to Start a Home-Based Craft Business,* also published by Globe Pequot Press.

Rosemary DeLucco-Alpert has been working in the photo industry for over twenty-five years as a freelance photographer, photo editor, curator, teacher, and lecturer. Her experience ranges from working with a photo stock agency in Los Angeles, editing images by *National Geographic* photographers, to teaching photography students at an art college in Connecticut. She had the opportunity to be one of Ansel Adams's last students, an experience that helped her articulate her passion and dedication to the medium of photography. Rosemary exhibits her work, has created a photo card line called "Intimate Landscapes," and continues to expand her photographic experiences both professionally and personally. She lives in Connecticut and has a Web site at www.rdalpertphoto.com